LIFE BOOKS

Managing Editor
Robert Sullivan

Director of Photography
Barbara Baker Burrows

Creative Direction
Li'l Robin Design, Inc.

Deputy Picture Editor
Christina Lieberman

Writer-Reporters
Michelle DuPré, Amy Lennard
Goehner, Daniel S. Levy

Copy Chief
Barbara Gogan

Copy Editor
Parlan McGaw

Photo Associate
Sarah Cates

Editorial Associate
Courtney Mifsud

Consulting Picture Editors
Mimi Murphy (Rome),
Tala Skari (Paris)

Editorial Director
Stephen Koepp

TIME INC. PREMEDIA

Richard K. Prue (Director), Brian
Fellows (Manager), Richard
Shaffer (Production), Keith
Aurelio, Jen Brown, Charlotte
Coco, Liz Grover, Kevin Hart, Mert
Kerimoglu, Rosalie Khan, Patricia
Koh, Marco Lau, Brian Mai, Po
Fung Ng, Rudi Papiri, Robert
Pizaro, Barry Pribula, Clara
Renauro, Vaune Trachtman

TIME HOME ENTERTAINMENT

President
Jim Childs

**Vice President, Brand & Digital
Strategy** Steven Sandonato

Executive Director, Marketing Services
Carol Pittard

**Executive Director, Retail & Special
Sales** Tom Mifsud

Executive Publishing Director
Joy Butts

**Director, Bookazine Development
& Marketing** Laura Adam

Finance Director
Glenn Buonocore

Associate Publishing Director
Megan Pearlman

Assistant General Counsel
Helen Wan

Assistant Director, Special Sales
Ilene Schreider

Senior Book Production Manager
Susan Chodakiewicz

Design Manager
Anne-Michelle Gallero

Brand Manager
Roshni Patel

Associate Prepress Manager
Alex Voznesenskiy

Associate Project Manager
Stephanie Braga

Special thanks: Katherine Barnet,
Jeremy Biloon, Rose Cirrincione,
Jacqueline Fitzgerald, Christine
Font, Hillary Hirsch, David Kahn,
Amy Mangus, Kimberly Marshall,
Nina Mistry, Dave Rozzelle,
Ricardo Santiago, Adriana Tierno,
Vanessa Wu

Copyright © 2013 Time Home
Entertainment Inc.

Published by LIFE BOOKS,
an imprint of Time Home
Entertainment Inc.
135 West 50th Street,
New York, New York 10020

SBN 10: 1-61893-100-8
ISBN 13: 978-1-61893-100-9
Library of Congress Control
Number: 2013943394

Vol. 13, No. 16 • August 2, 2013

"LIFE" is a registered trademark
of Time Inc.

We welcome your comments and
suggestions about LIFE Books.
Please write to us at:
LIFE Books
Attention: Book Editors
PO Box 11016
Des Moines, IA 50336-1016

If you would like to order any of
our hardcover Collector's Edition
books, please call us at 1-800-
327-6388 (Monday through
Friday, 7 a.m.–8 p.m., or Saturday,
7 a.m.–6 p.m., Central Time).

Front cover: PHOTOGRAPH BY
TRISTAN GREGORY/CAMERA PRESS/
REDUX
Back cover: PHOTOGRAPH BY
TRISTAN GREGORY/CAMERA PRESS/
REDUX
Page 1: Harrison, Charlotte and
Matthew were in bed when they
heard the news and rushed to
Buckingham Palace, still in their
royal pajamas, to celebrate.
PHOTOGRAPH FROM NATIONAL
NEWS/ZUMA
Pages 2–3: The ship's company of
the HMS *Lancaster* announces
the news on July 22, 2013, while
on patrol in the Caribbean.
PHOTOGRAPH FROM CAMERA PRESS/
ED/RM/REDUX
These pages: The little Prince of
Cambridge.
PHOTOGRAPH BY JOHN STILLWELL/AP

All Hail!

His Royal Highness
Prince George of Cambridge

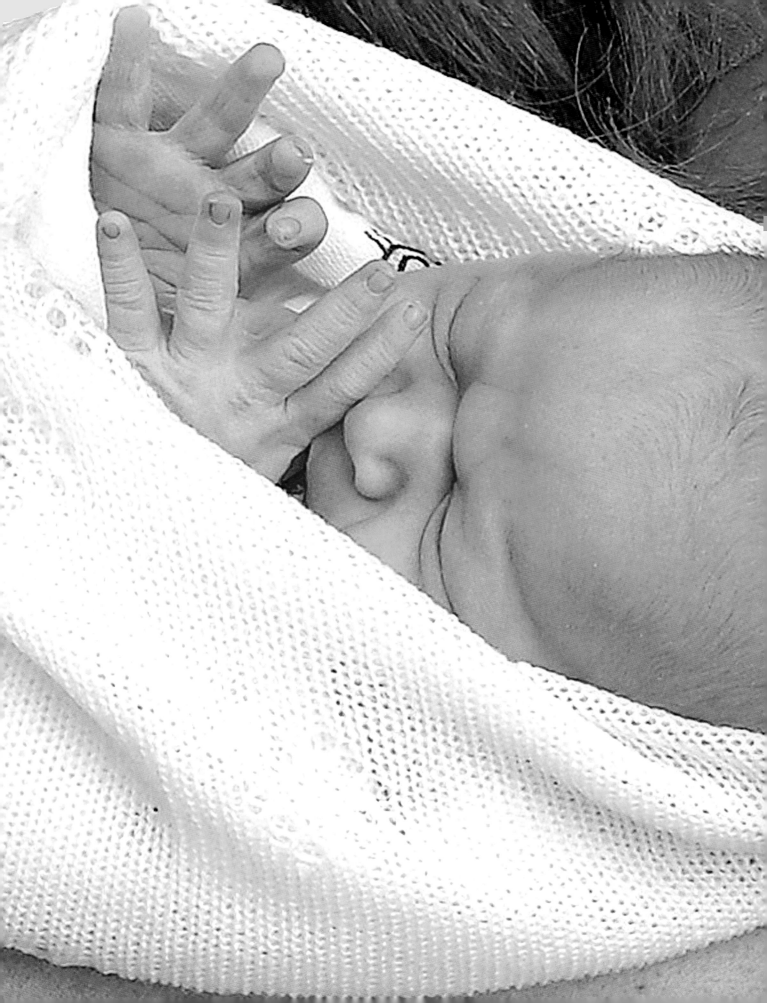

It's a *Boy!*

Finally, smack-dab in the middle of July, the queen herself weighed in, with some good-natured impatience if not perturbation. "I would very much like it to arrive," she said of her coming great-grandchild. "I'm going on holidays." She spoke for everyone, the whole world 'round. It's not that we who happily call ourselves "royals watchers" had tired of the always lovely (and ever-larger) Kate, or of the boy-girl guessing game, or of the laying of bets at Ladbrokes on this name or that one—we hadn't tired of any of that. But, blimey, we wanted to pop the cork, raise the glass, celebrate! We wanted the royal baby. And we wanted it *now*.

And we finally got it—him!—on the following Monday, His Royal Highness the Prince of Cambridge. He was not, as Kate's mother had predicted, an astrological Leo (that star sign commenced its cycle on July 23) but a Cancer, having been born on the 22nd. No matter, all good.

Why the birth of this baby injected more than $350 million into the British economy is best explained by others, but we accept that it did, and as far as LIFE is concerned, that's great, for a foofaraw of this scale translates into terrific, festive, happy pictures, plus wacky trivia and side stories to accompany. It has ever been thus. In this book, we celebrate William and Kate and their new baby, to be sure, but we celebrate as well this entire idea that has had its recent, glorious renewal in London: the idea of royal babies. These are, even as they are

swaddled, the luckiest kids in the world, and the most showoff-worthy. They are graced with not only Savile Row snugglies but practically perfect parents and predestined courses in life. For all that, somehow, they belong to all of us, and their journey, wayward or straightforward, will be monitored by us on an annual—even monthly or weekly or daily or, God forgive us, *hourly*—basis. You'll see what we mean, in the pages that follow. We've monitored these children before, in LIFE's pages and elsewhere, and now we have a new one to watch out for. And, trust us, we will.

This new royal child is a Windsor (which clan you will learn more about shortly). This does not today cause the shiver of anxiety that it might have only a few years ago. He is the offspring of the attractive William and Kate, two seemingly steadfast and intelligent young people (rather against the Windsor grain, with such as Elizabeth II and George VI obvious exceptions to that comment) who might well produce a worthy monarch. Of course, when he becomes a monarch, he will be a monarch in a "constitutional monarchy," which is to say: He will have no real power. But he will be king of England one day, and that's special.

LIFE magazine was born in 1936, and that year we had the abdication of Edward VIII to cover. As we progressed through World War II, so did Edward's brother and estimable successor, George VI, and the queen consort (later beloved as the marvelously be-hatted centenarian "Queen

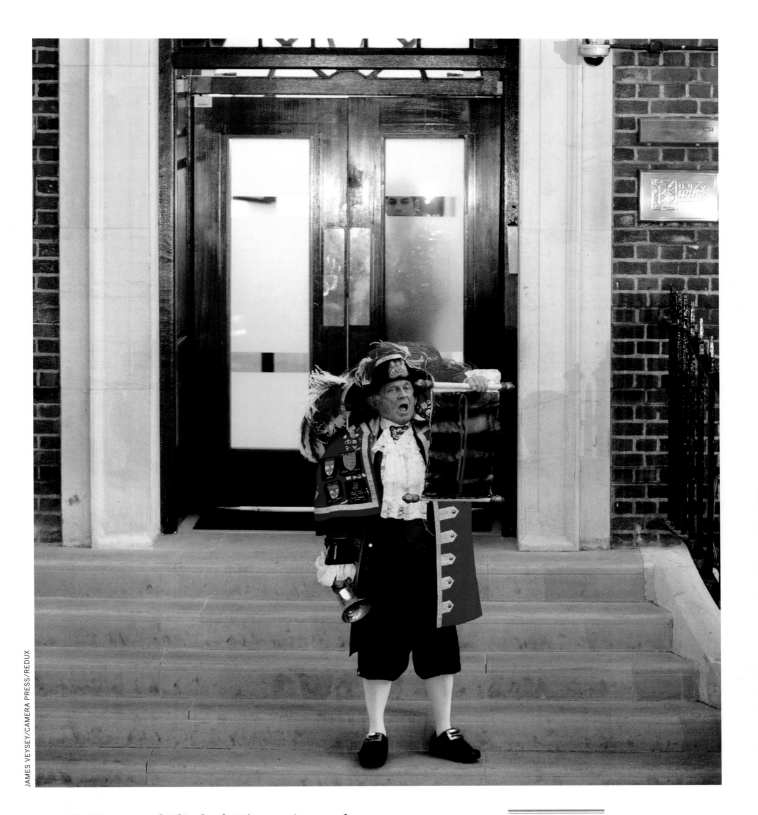

Mum"). We covered Elizabeth II's marriage and coronation and jubilee. We grew up with Charles, and then were there with Di. Wills was a baby in our pages, and now he is a dad. And Harry is an uncle.

What to say about all this?

How about: *Huzzah!*

HEAR YE, HEAR YE: There'll always be an England! When the royal baby is born on July 22 the news is blared on the steps of St. Mary's Hospital's Lindo Wing in London by traditionally garbed (and self-appointed) town crier Tony Appleton.

Princes *and* Princesses

Trumpets!
Hooray, Huzzah and Felicitations—we have a new royal baby in the House of Windsor! Which, for many of us (especially of the American species), begs the question: What exactly is the House of Windsor?

The answer to that isn't simple, but in an attempt to make it short (or shortish): What is now known as the House of Windsor is an ostensibly English family that has been producing royal babies, some of whom have grown up to become kings or queens of the United Kingdom and other European countries, since the time of the legendary Queen Victoria.

We say *ostensibly* English with purpose. Victoria, who ascended to the throne in 1837 to begin a 63-year reign (the longest to date of any British monarch; Elizabeth II, at 61 years now, is closing in fast) and who would be the last ruler of the House of Hanover, was the granddaughter of George III and the niece of King William IV, who immediately preceded her as British sovereign. So she was a proper claimant. However, she was of mostly German descent; her father was Prince Edward, Duke of Kent and Strathearn, and her mother was Princess Victoria of Saxe-Coburg-Saalfeld. The young queen married Prince Albert of Saxe-Coburg-Gotha, son of the German Duke Ernest I, and that only made matters more Germanic. Which was all well and good for a while. Victoria wanted her son, when and if he ever did get to succeed her, to rule as a representative of the House of Wettin, a thousand-year-old German family of which Saxe-Coburg was a branch. This, she felt, would properly celebrate England and Germany's shared Saxon heritage. And indeed her eldest son, Edward VII, did reign as a member of Saxe-Coburg-Gotha, as did his own son George V. But then, with the advent of World War I, Brits began to feel none too chipper about all things Germanic. On July 17, 1917, George V made a masterful PR move, as kings are allowed to do, when he decreed, "Now, therefore, We out of Our Royal Will and Authority, do hereby declare and announce that as from the date of this, Our Royal Proclamation, Our House and Family shall be styled and known as the House and Family of Windsor." Windsor was, of course, *veddy, veddy* British, what with the town in the county of Berkshire and the royal castle situated there.

So there you have it: "the Windsors" from World War I onward, with many babies to follow.

THIS PORTRAIT, made in 1885, shows three great-grandchildren of Queen Victoria and their German nurse, embodying the duality of their Windsor roots. In the Fauntleroy suit with the lace collar is Prince Wilhelm: the boys still in skirts are Prince Eitel Friedrich (right) and Prince Adalbert. Their grandmother Vicky was both queen of Prussia and Princess Royal of Great Britain, which was perfectly fine.

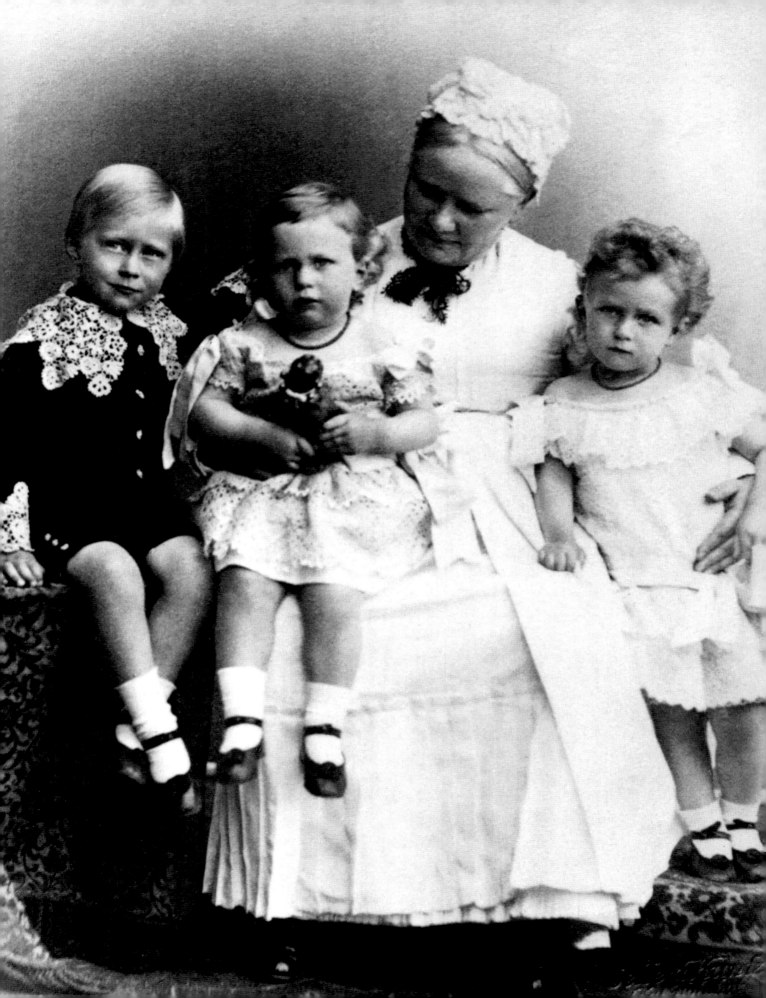

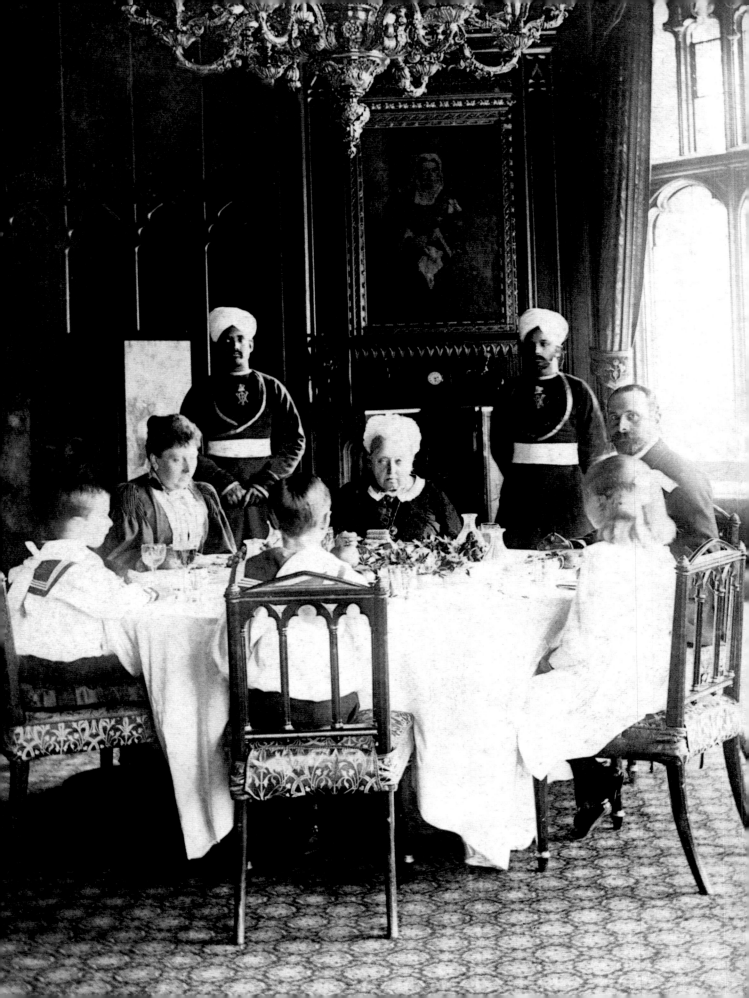

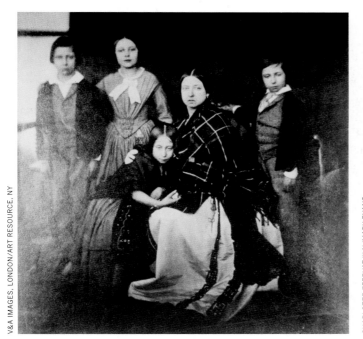

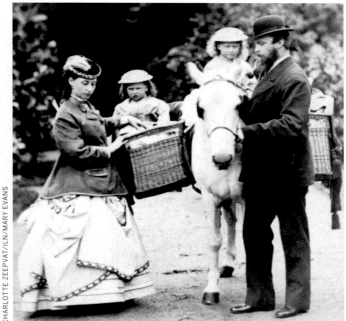

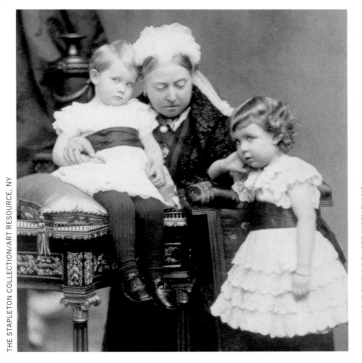

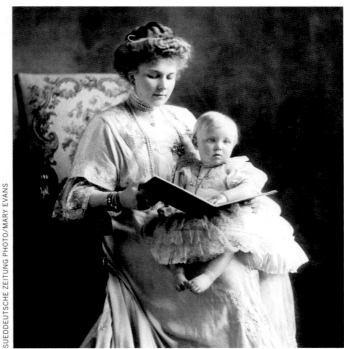

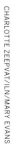

GET YOUR SCORECARDS READY and your pencils sharpened. Above, clockwise from top left (and trust us, please, that these folks are all related as parts of the clan today known as "Windsor"): The Prince of Wales, the Princess Royal, Princess Alice, Queen Victoria and Prince Alfred; Princess Alice again (second daughter and third child of Victoria, by the way), her husband, Grand Duke Louis of Hesse, and two of their seven children, Victoria (beside her father) and Elizabeth, in England in the mid-1860s; Queen Victoria Eugenie of Spain with her first child, Alfonso, Prince of Asturias; Victoria with grandchildren Prince Arthur and Princess Margaret of Connaught in 1886. Opposite: In 1895, Victoria, attended by Indian servants, with Princess Beatrice and Prince Henry of Battenberg and three of their four children: Leopold (left, on the cushion), Alexander (gazing at Grandmum) and Victoria Eugenie.

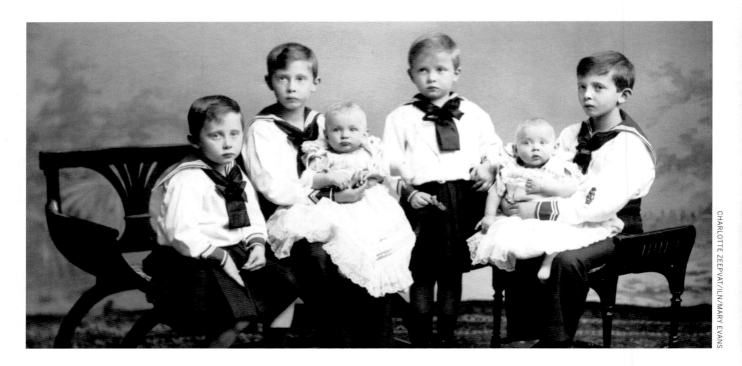

MORE FROM THE FAMILY *that will be called Windsor, as the Victorian era progresses. (On this page, we note first that sailor suits especially but even army get-ups have long been part of royal-baby haberdashery.) Not quite at sea in the top photo are, from left, the children of Victoria's granddaughter Princess Margarete of Prussia and Prince Frederick Karl of Hesse-Kassel: Wolfgang, Friedrich Wilhelm, Richard, Philipp, Christoph and Maximilian. In the bottom photo, from left: Prince Albert of Wales, who would later be the Duke of York and then England's King George VI, along with Prince Olaf of Norway and Prince John in 1908. Opposite: Please focus on the girl on the tree trunk, not yet royal but a member of the British aristocracy in the first decade of the 20th century, and a Windsor you know of. She is Lady Elizabeth Bowes-Lyon—seen here with one of her nine siblings—who will marry Prince Albert and then, when he becomes King George VI, will be the United Kingdom's queen consort. More on her on the following pages.*

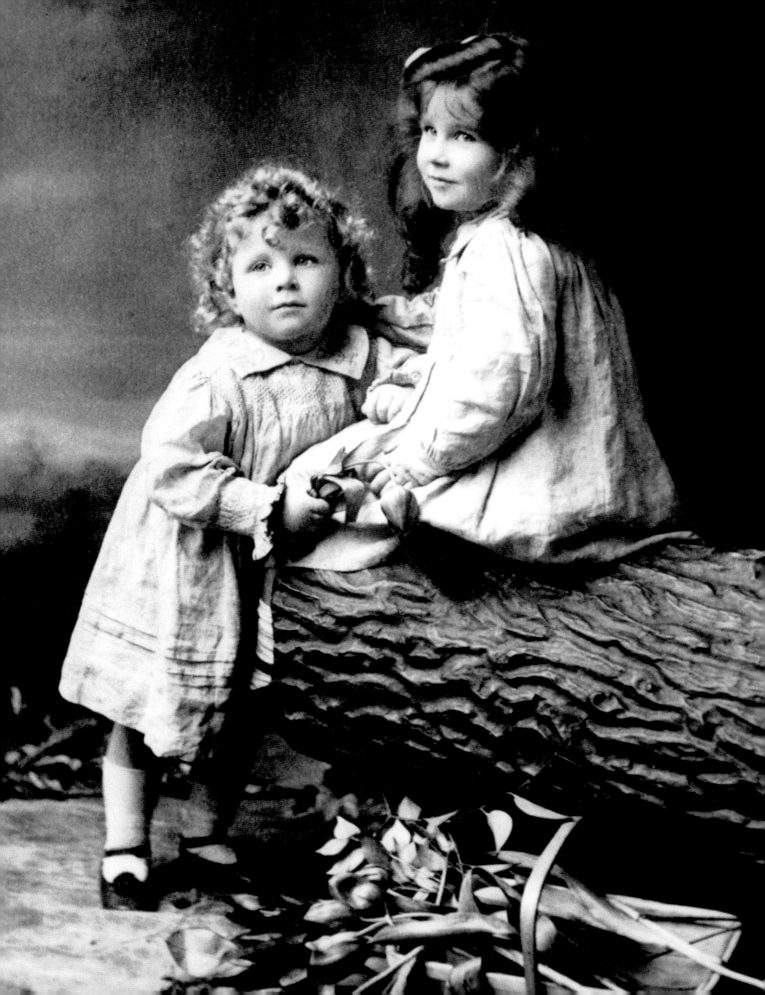

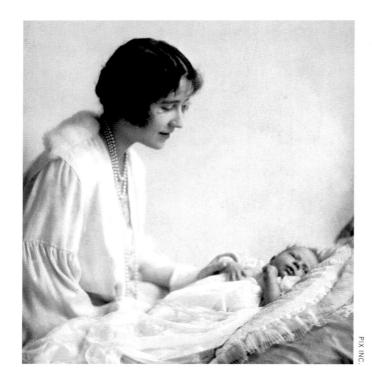

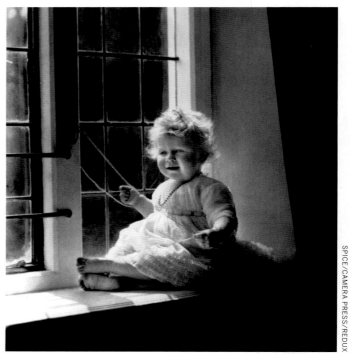

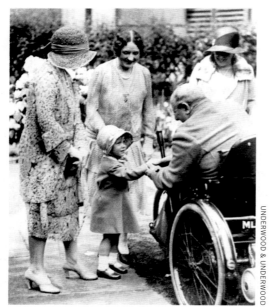

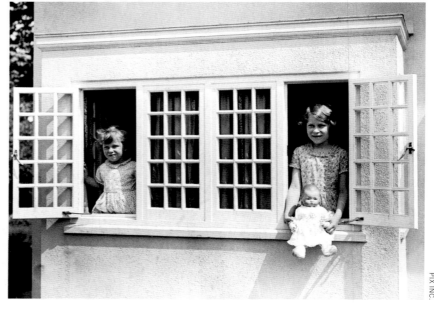

FANS OF THE FINE MOVIE The King's Speech *know all about George VI, his wife, and their noble behavior during World War II. Their first child, a girl, also named Elizabeth, who would be queen one day, was born a royal in 1926 when they were still the Duke and Duchess of York (top left, mother and child; top right, Elizabeth at age one, staying at the home of her grandparents Lord and Lady Strathmore in Hertfordshire while her parents are touring Australia and New Zealand). As a girl, Elizabeth is seen above, left, shaking hands with an ex-serviceman at a Disabled Soldiers Embroidery Industry exhibition; above, right, playing outside the Royal Lodge in Windsor with her sister, Princess Margaret, in 1936; and opposite, at right, with Margaret and Mum. In December of '36, Albert becomes King George VI upon the abdication of his brother, and Elizabeth becomes first in the line of succession. Her father will sit upon the throne until his death in 1952.*

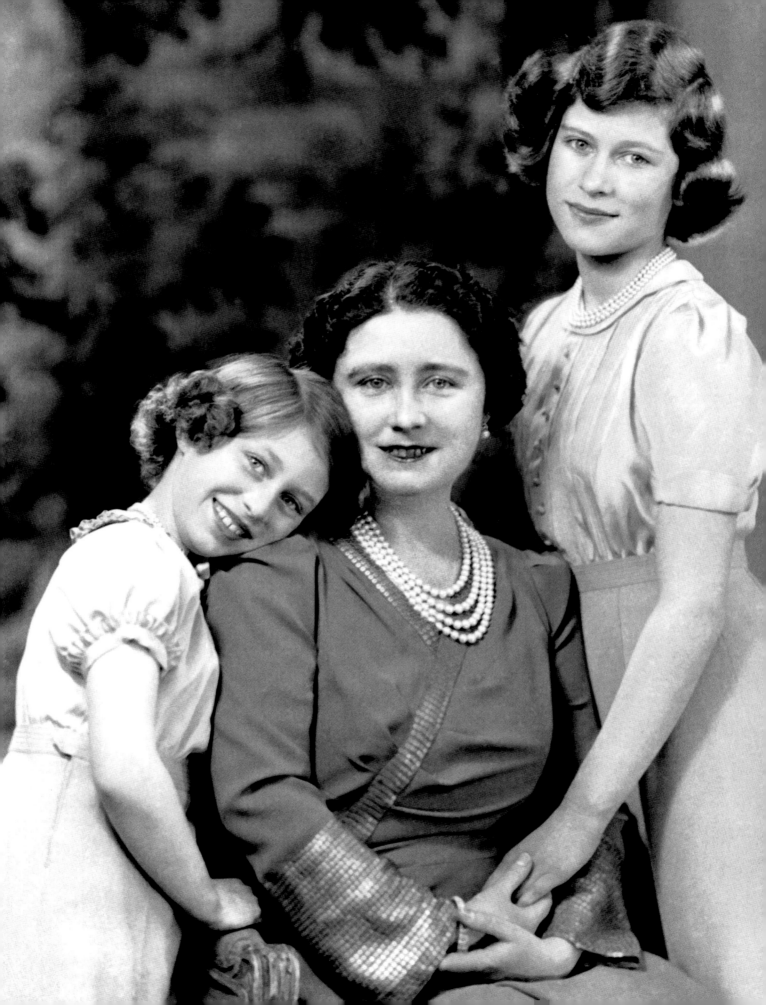

When *Charles* Was "the Royal Baby"

Things were different in 1948. In the United States, LIFE did not spend the summer and autumn running weekly updates on Princess Elizabeth's baby bump for an insatiable audience. And yet, certainly, everyone around the world, and especially in England, knew Prince Philip's wife was expecting. Late at night on November 14, the word came to most Britishers by way of the instrument that had become an essential part of their daily life during the war. "This is the BBC Home Service," intoned the newsreader, John Snagge, decorously. "It has just been announced from Buckingham Palace that Her Royal Highness Princess Elizabeth, Duchess of Edinburgh, was safely delivered of a prince at 9:14 p.m., and that Her Royal Highness and her son are both doing well." Snagge hardly broke professional protocol when he presumed to add: "Listeners will wish us to offer their royal congratulations to Princess Elizabeth and the royal family on this happy occasion. We play the national anthem in honor of the prince." And the music issued forth.

As did Londoners from throughout the city, who streamed toward Buckingham Palace, where Charles had been born, despite the late hour. There, in a public celebration well practiced since the defeat of Germany, thousands chanted, "We want Philip! We want Philip!" demanding that Dad appear on the balcony, and when he did, they sang "For He's a Jolly Good Fellow." The BBC reported to the hinterlands that the throng showed "no sign at all of . . . dispersing," and again went personal: "At this moment, we outside the palace feel more than ever that we are united in feeling and loyalty with their majesties the king and queen." The announcer also said, with British understatement: "It's been an exciting evening."

Charles was indeed a prince, but interestingly, that was a near thing. As a child of a daughter of the king, he wouldn't be entitled to the honorary style Royal Highness. But three weeks before he was born, George VI changed the rules and said that any children born to Princess Elizabeth and the Duke of Edinburgh would be accorded princely status from the first moment.

Other rules would be bent or broken with (and by) this boy of the 20th century, this elder statesman of all British baby boomers. Certainly he had a governess (Catherine Peebles), but then he went to school rather than be tutored at the palace—the first-ever British heir apparent to be thus educated.

He had been born to ancient tradition in a modern age and would seem a man of two worlds his whole life.

FOUR GENERATIONS of Windsors at Buckingham Palace: King George VI (born Albert Frederick Arthur George in 1895); his daughter Princess Elizabeth, the future queen, born in 1926; his mother, Queen Mary, born Princess of Teck in 1867; and his first grandson, Prince Charles, born just now in 1948.

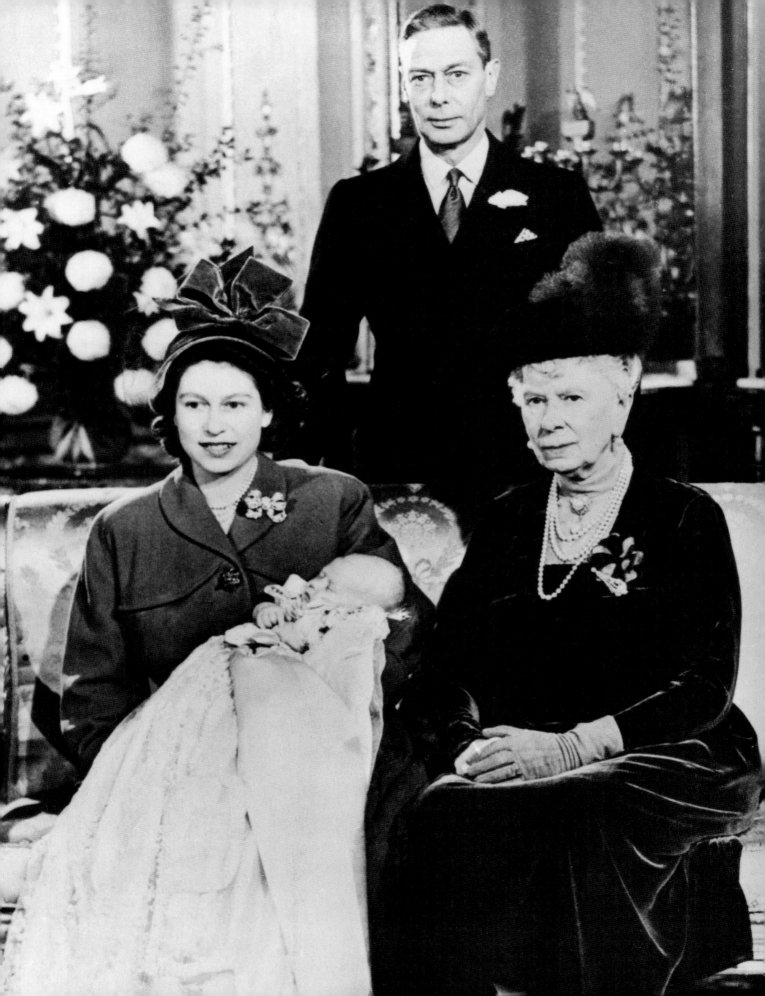

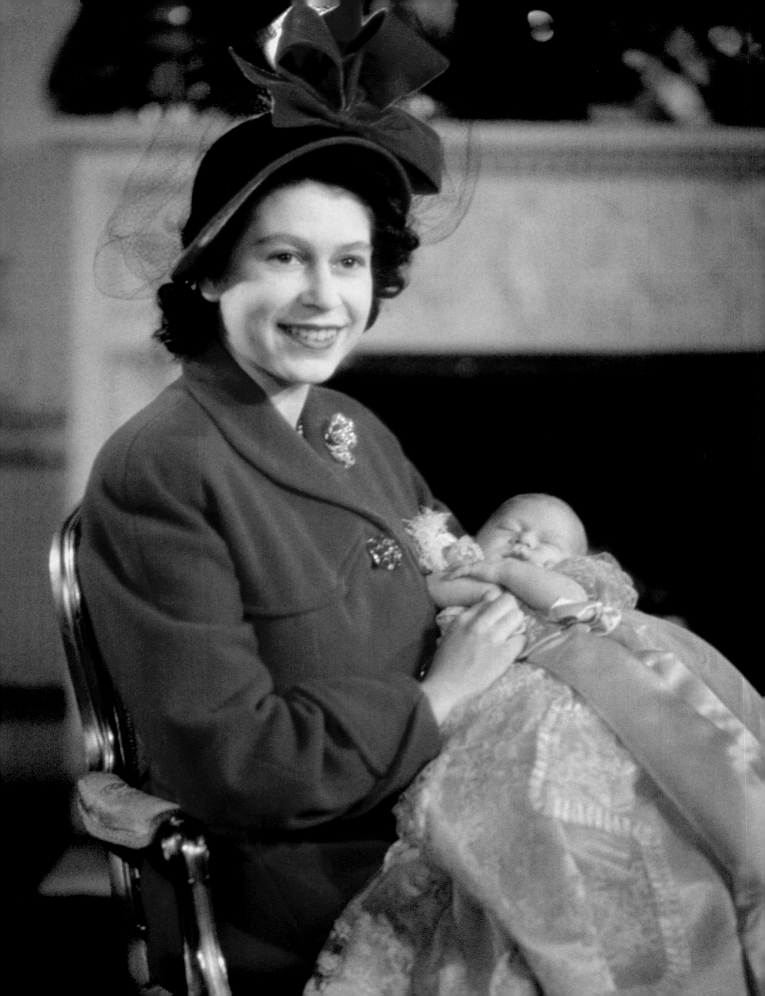

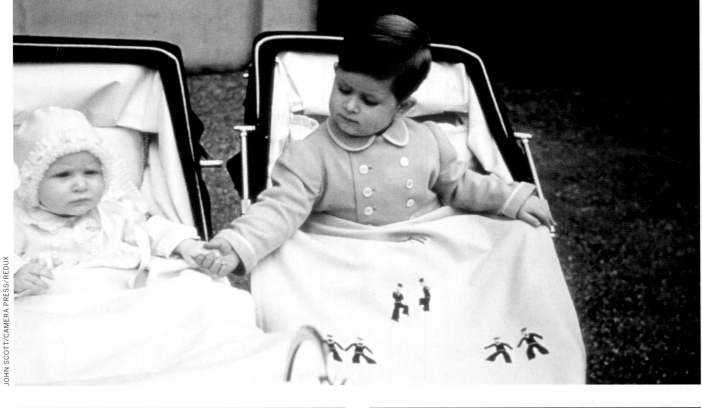

JOHN SCOTT/CAMERA PRESS/REDUX

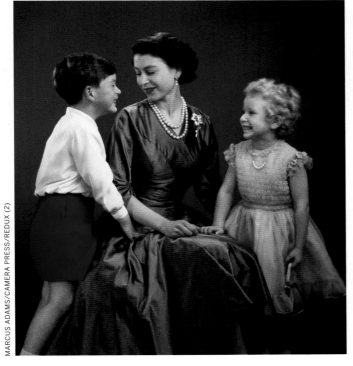

MARCUS ADAMS/CAMERA PRESS/REDUX (2)

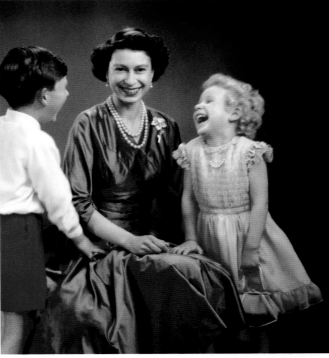

BARON/CAMERA PRESS/REDUX

CLOCKWISE FROM THE OPPOSITE PAGE: *Princess Elizabeth holding her newborn son, Prince Charles, who is wearing his royal christening gown (he is being baptized this December day in the Music Room of Buckingham Palace); three years later, in 1951, Charles holds hands with his baby sister, Princess Anne; and then a sequence made in 1954, after Elizabeth has become queen upon the death of George VI, with her two elder children.*

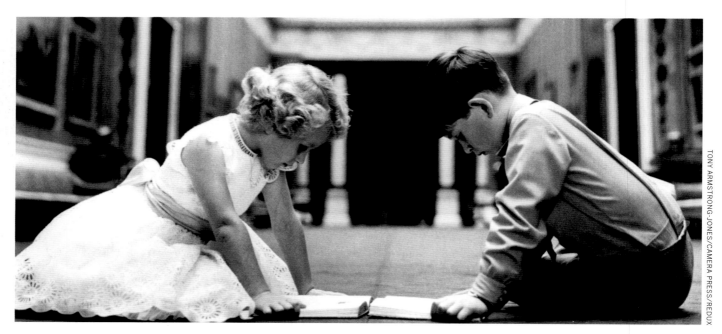

TOPICAL PRESS AGENCY/GETTY

TONY ARMSTRONG-JONES/CAMERA PRESS/REDUX

CECIL BEATON/CAMERA PRESS/REDUX

TOP: On June 2, 1953, Queen Elizabeth is having her coronation ceremony at Westminster Abbey, an altogether thrilling event, though you cannot tell this by observing young Charles, head on hand, seated between the Queen Mother (George VI's widow, the former Lady Elizabeth Bowes-Lyon, who is about to transition into Britain's beloved "Queen Mum") and Queen Elizabeth II's younger sister, Princess Margaret. Above: Charles and Anne have a nice place to study, the Picture Gallery at Buckingham Palace, in November of 1956. Opposite: Another royal baby! Prince Charles holds the hand of his newborn brother, Prince Andrew, in March of 1960.

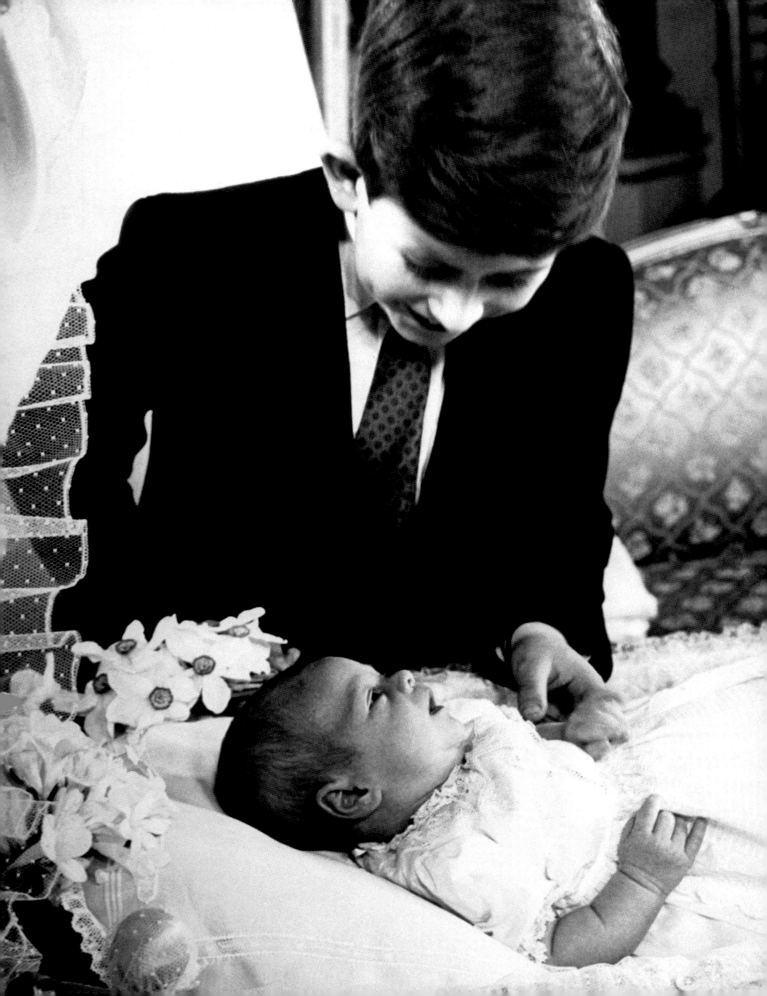

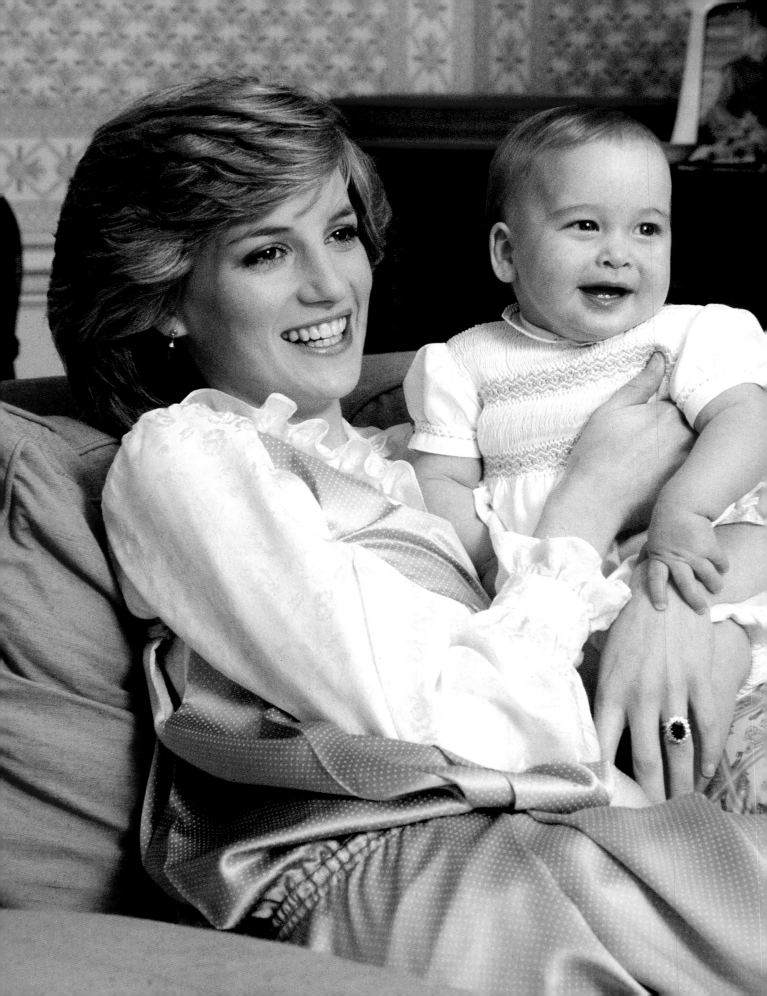

When *Wills* Was "the Royal Baby"

There could be no book involving Prince William—or Prince Harry, or Prince William's child—without substantial attention paid to the mother (and deceased grandmother), the former Lady Diana Spencer. This chapter is about the birth and earliest years of the boy known to his family (and then to all of England) as Wills. Yes, it's about him. But it is as much about Diana, one of the most riveting figures of the 20th century, a princess like none before, nor since.

She, the fourth child of Edward John Spencer, 8th Earl Spencer, and his wife, Frances, daughter of Edmund Maurice Roche, 4th Baron Fermoy (none of this an exceedingly big deal, but still an aristocratic deal), was very pretty, tall, shy, anti-intellectual, fashionable and popular. School might not have been her thing, but empathy was: Even as an adolescent, engaging invalid seniors during field trips, she sensed that she had found her calling. Once she had been courted by, and then married to,

Charles, in the so-called Wedding of the Century at St. Paul's Cathedral in 1981 (watched by 750 million telly viewers worldwide, with 600,000 Brits waiting to greet her in the streets), she found herself, contrarily, both overwhelmed and in her métier. She didn't want to hang out with the royals at Balmoral (as she learned emphatically during her honeymoon). She did want to bend her knees and commune with children on their level (unprecedented in the royal family, and a gesture Kate has mastered beautifully) and to find ways to help the world's downtrodden—if she possibly could. We all know that she and Charles were not meant to be and that they divorced and that she died in a car crash in Paris in 1997, but meantime . . .

She wanted to be a mother, and she was to be a splendid one. On November 5, 1981, it was announced that she was pregnant, and her countrymen cheered. Two months later she fell down the stairs at the royal estate at Sandringham, and her countrymen gasped. The royal gynecologist Sir George Pinker said everything was still okay, and her countrymen cheered once more. On June 21, 1982, in the private Lindo Wing of St. Mary's Hospital in the district of Paddington in London, Sir George and associates delivered her of a son, who moved right into line behind his father, Charles, as heir to the throne. The boy was named William Arthur Philip Louis by Diana (she named both her boys, and always chose their schools) and would be called Wills.

OPPOSITE: Baby Wills is exuberantly happy with Diana, and would remain delighted with her, and devoted to her, for the rest of her too-short life. She, not Charles, actively raised her boys while living at Kensington Palace, just off Hyde Park in central London. William and Kate plan to raise their own children there as well.

TIM GRAHAM/GETTY

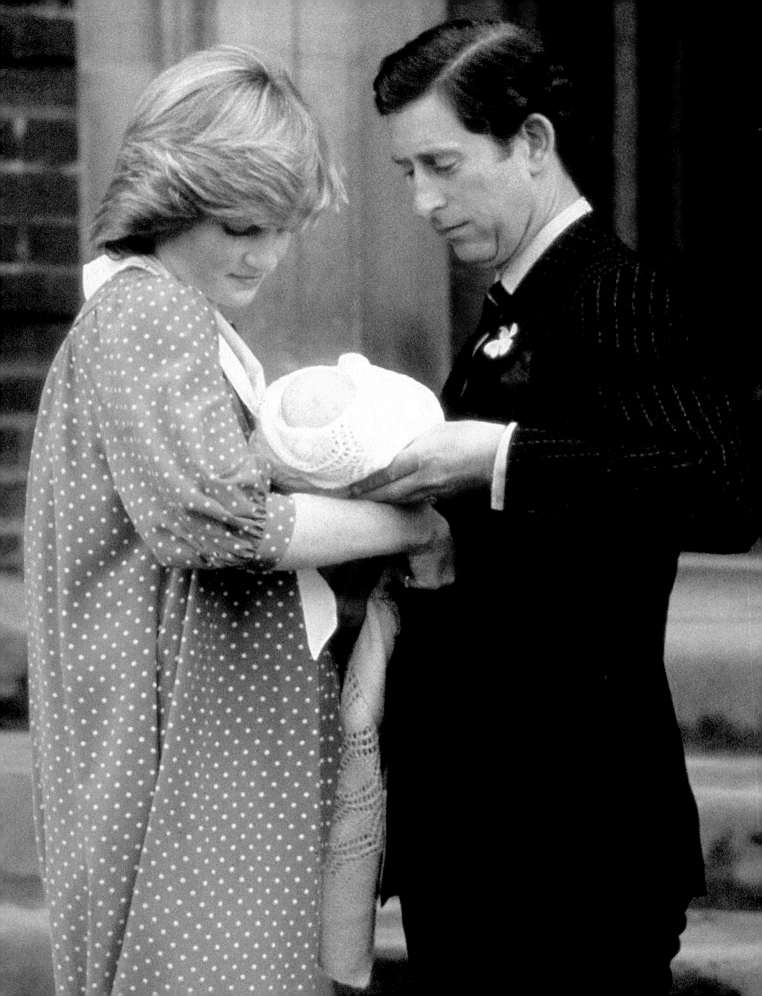

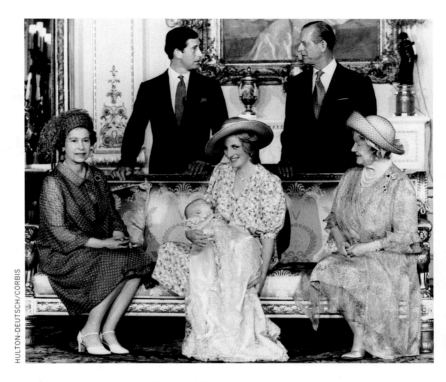

HULTON-DEUTSCH/CORBIS

OPPOSITE: On June 22, 1982, the Prince and Princess of Wales take their newborn son, Prince William, from St. Mary's Hospital. Right: A portrait of members of the royal family after the birth of Wills. Left to right, we have Queen Elizabeth II; Prince Charles, Princess Diana, holding Prince William; Prince Philip, the Duke of Edinburgh (and also Elizabeth's husband and Wills's granddad); and Elizabeth, the Queen Mother. (So then, once more: four generations of Windsors at Buckingham Palace.) Below: Wills, in February 1983, is held by his father and mother at the Waleses' family home, Kensington Palace.

TIM GRAHAM/GETTY

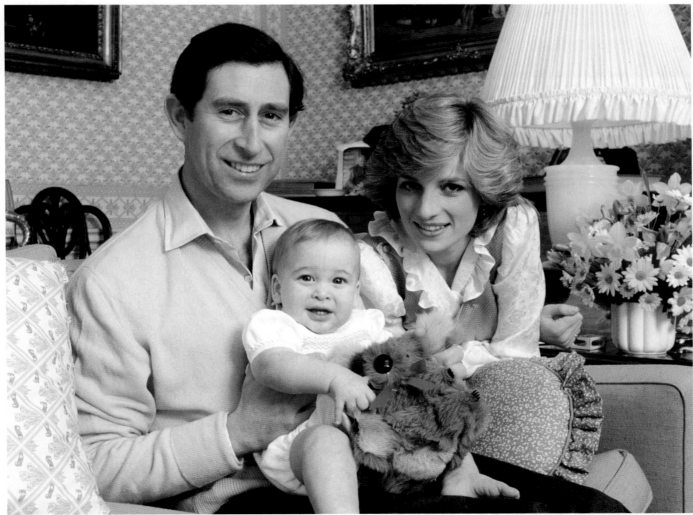

JOHN REDMAN/AP

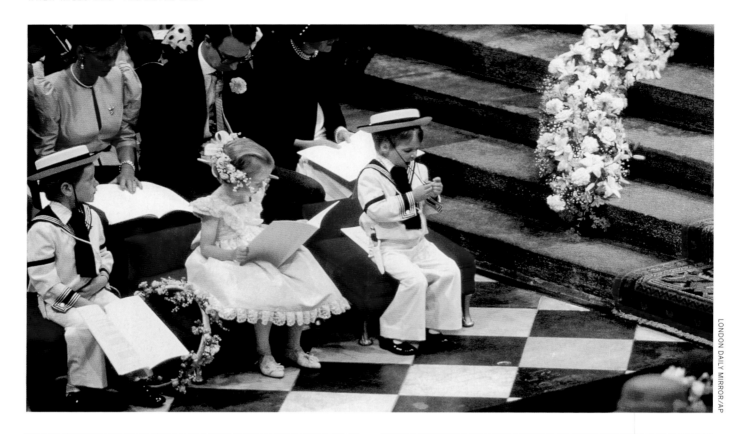

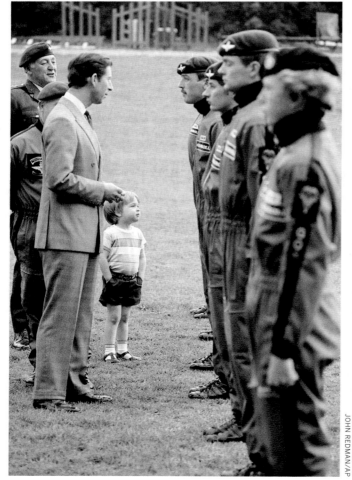

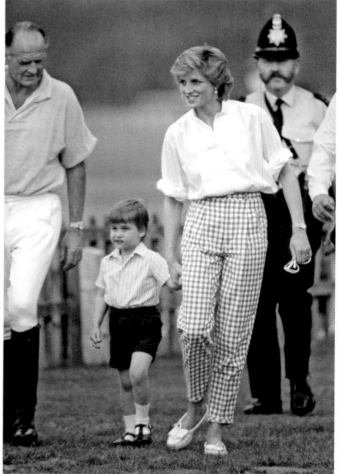

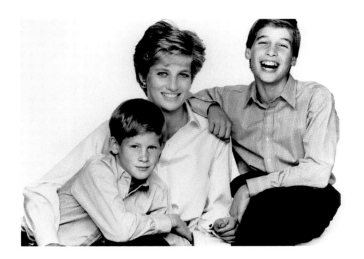

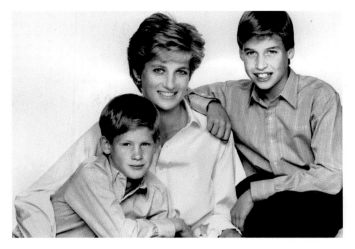

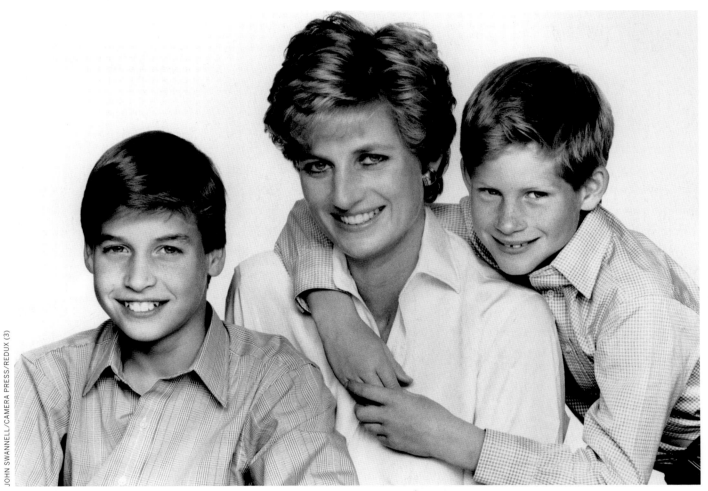

JOHN SWANNELL/CAMERA PRESS/REDUX (3)

OPPOSITE, TOP: *Four-year-old page boy Prince William of Wales fidgets with his hat strings while sitting beside bridesmaid Laura Fellowes during the marriage of his father's younger brother, Prince Andrew, and Sarah Ferguson at Westminster Abbey on July 23, 1986. Below, left: Charles and Wills meet members of the British Army Red Devils parachute team after a jump into the gardens of Kensington Palace. Right: Wills, Diana and Major Ronald Ferguson, Fergie's father, during a polo match at Windsor in '86. Above: Portraits made in 1994 of Diana and her two boys, Wills and Harry—who were devoted brothers then and remain devoted brothers today.*

Born to be a *Princess*

And when we say "born to be a princess," we mean it in the sense that all of our daughters, lovely in our eyes, were born to be princesses. Kate Middleton wasn't a royal, nor even an aristocrat. She was, when she first came on the celebrity scene at the turn of the millennium, the daughter of an airline pilot and a flight attendant whose family backgrounds were more blue than white collar, but who had struck it rich after founding a mail-order party supplies company in 1987. Kate was a university student at St. Andrews in Scotland in 2001 when she met and began a friendship, then a romantic relationship with a fellow student, none other than Prince William. They persevered through the glare for a full decade, with a split and subsequent reconciliation in 2007. Today, with the birth of her and William's first child, some have said that she was the best thing that ever happened to him.

Why would they make such a claim? Well, William must have had issues after witnessing the constant bickering in his parents' marriage, and having both seen and experienced for himself the oppressiveness of public scrutiny and the damage it can do. Kate entered his life with no such baggage, and perhaps with a perspective so entirely alien to a royal that it was not only refreshing but irresistible. That, of course, is the type of foundationless pop psychology in which there is no profit. But clearly she was good for him and loved him. And clearly, as the pictures in this book attest, he loved her from the first.

Strangely, William's experience in the relationship is easier to figure than Kate's. How in the world did Catherine Elizabeth Middleton, born on January 9, 1982, the first child of Michael and Carole, who still live today in a quaint English village with the central casting name of Bucklebury, survive all that has transpired since she met her literal and figurative prince? The short answer: a good, solid upbringing. The environment made by the senior Middletons for their kids, Kate, Pippa and James, was loving. (Prince William, once welcomed into it, couldn't get enough of it, sometimes skipping off on his motorbike for a bit of home cooking.) Kate, when asked by a television interviewer post-engagement why she so often went back to Bucklebury, answered simply, "It's very important to me. We see a lot of each other . . . [My parents] are very, very dear to me."

Reportedly, her mother, not a royal nanny or nurse, is going to help her through the first weeks of motherhood. It's what mums in Bucklebury do for their daughters.

KATE IS THREE AND A HALF as she scrambles over the rocks during a family vacation in England's Lake District.

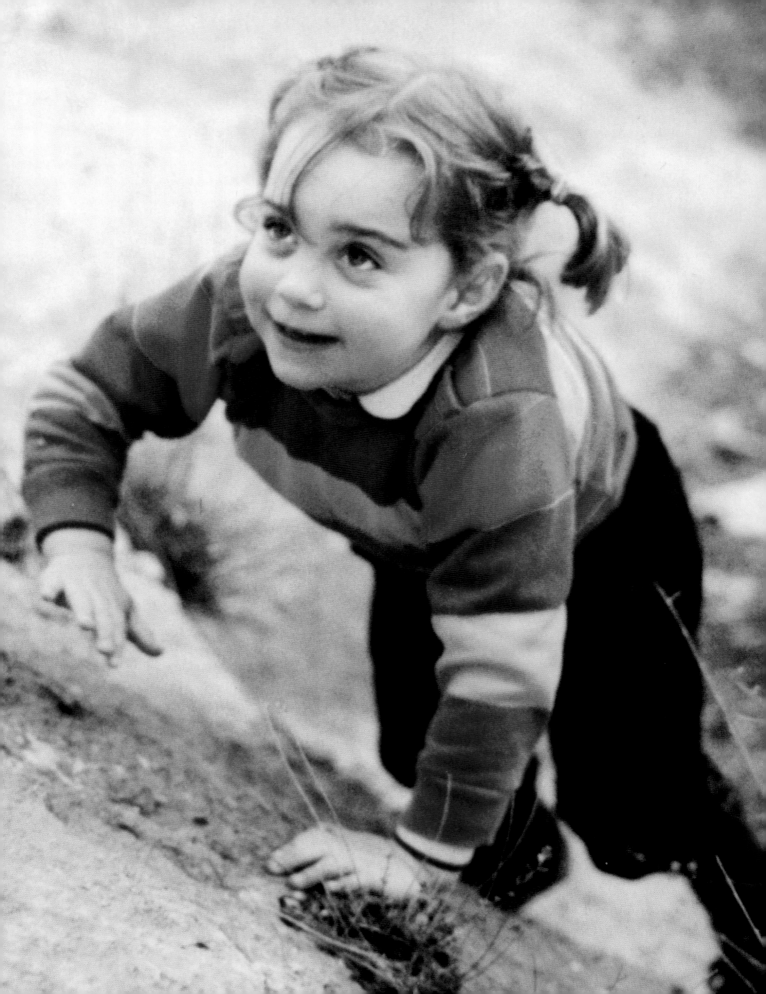

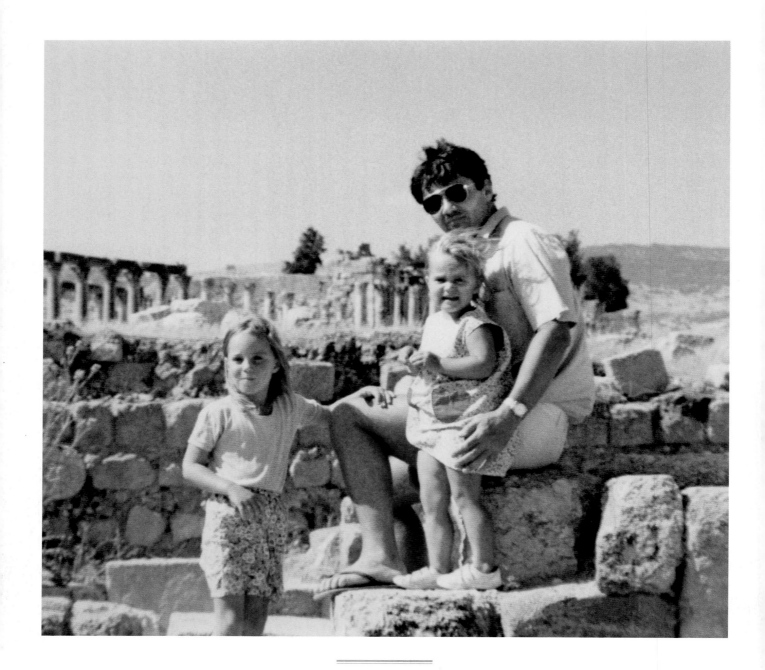

IF AUSTEN OR DICKENS had written the romance of William and Kate, the author might have called the clan from which the bride emerged "the Middletons." The reader would have inferred immediately: middle, middle class, centered, something other than upper and probably weightier, more grounded, more real—the kind of folks who, if they could swing it, might vacation in the Lake District. Or, in hale years, even take a trip abroad. In the photograph above: Kate is four years old and seen with her younger sister, Philippa, today world-famous as Pippa, and their dad, Michael, during a 1986 trip to Jerash, Jordan. Opposite: The following year, the princess to be, already a princess to Michael and Carole, is five.

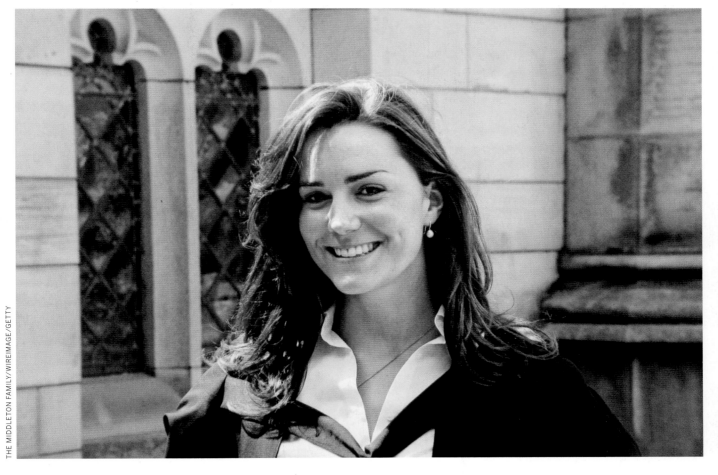

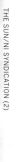

SHE HAS ALWAYS been sporty: her athleticism is part of her being. At St. Andrew's School in Pangbourne, Berkshire, a coed prep school she began attending at age four in 1986, the yearbook from June 1995, her final year, talks of her playing on the netball, rounders and field hockey teams, as well as winning her age-group cup for outstanding sporting achievement. It does not mention how high she could jump or how fast she could run during School Sports Day. In the third photo on the opposite page, she is still at St. Andrew's, seated at left, during St. Andrew's Day festivities. She would later matriculate at a second place of learning named for St. Andrew: the university. During her gap year, she spent time working in Chile with classmates; unbeknownst to her, Prince William had done the same only one term earlier. Above: Graduation day at the university in 2005.

Royal Babies
'Round the World

In late May in the London newspaper *The Guardian*, Hadley Freeman wrote in part: "Royal babies have been born before, but never before has one been born in an era in which the media has been so shamelessly obsessed with—in no particular order—babies, celebrities (ideally of the female variety), maternal body weight, parenting, motherhood, fashion, finding a replacement for Princess Diana, tedious first-person journalism, unashamed criticism of women, blogs, blogs for mothers, blogs about mothers . . ."

Point taken, Ms. Freeman, but the point we choose to emphasize just now is in your lede: *Royal babies have been born before.* We have already met several of the Windsor stripe, but believe it or not: Royal babies are not endemic to England. They have long been, in fact, something of an invasive species on a global scale. They pop up regularly in the usual places, and sometimes in surprising places. On occasion they are Germans born in London, sometimes they are Japanese born in Japan, and then if we're at all lucky they are attractive kids born in Monaco—a constitutional monarchy with a land border of less than three miles and a population approximate to that of a midrange American suburb—to a former Hollywood movie star who happens to be among the two or three most beautiful people on the planet.

Royal babies differ from the rest of the world's babies and young children in precisely the same way their parents differ from the rest of us adults: They are richer, they are better groomed and they are required to wear, all too often, really funny clothes—funnier than the pink pajamas with the rabbit ears in *A Christmas Story*—"He looks like a deranged Easter Bunny!" Exhibit A is seen on the opposite page.

Many royal babies have grown to be benevolent rulers. Many have become well-behaving figureheads. Many have become despots, murderers of their own people. Some of these diverse courses are precluded for William and Kate's child; England, which since the late 19th century has been a constitutional monarchy and which today clings to the crown for reasons of its own—some of these having to do with sentiment (or even tourism)—will never again suffer a tyrannical king or queen. We can be sure of that.

But future outcomes are not the principal consideration when we behold a royal baby (or, for that matter, any baby). What registers—and we defy you to resist it here and in the 10 pages to follow, is:

How cute is *that!?*

HE IS NOT the front man for a heavy metal boy band. He is, circa 1906, three-year-old Prince Nicholas of Romania, known alternately as Nicky, and Nicola. He, too, is mixed up with the English royals—aren't they all?—but his main titles and positions will issue from Romania.

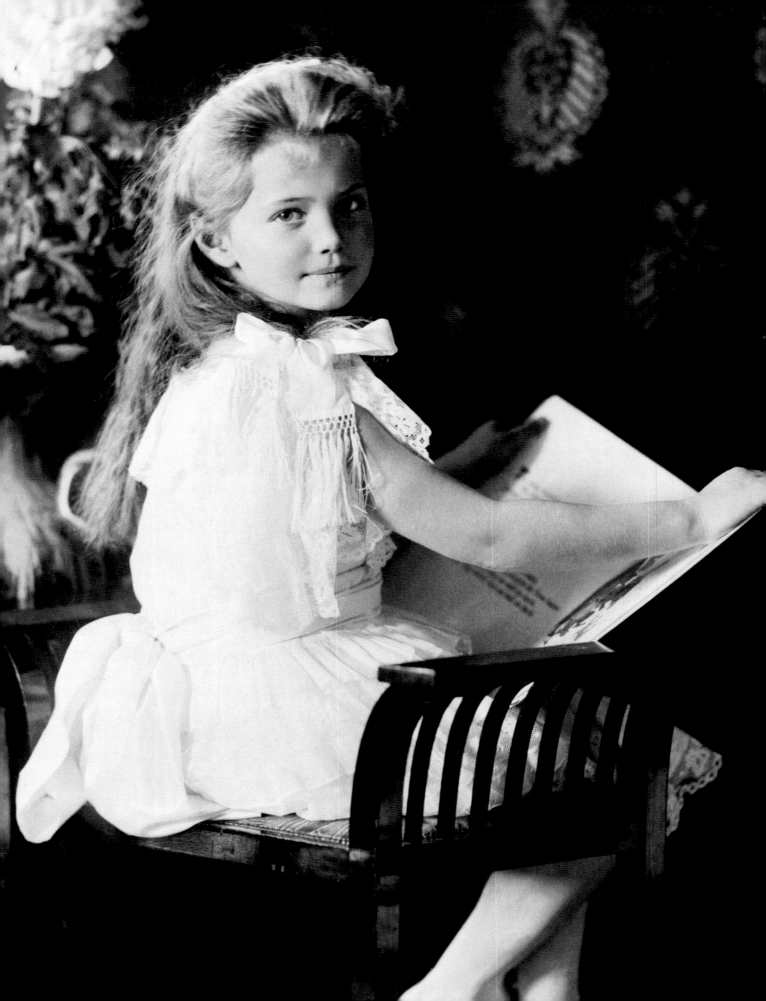

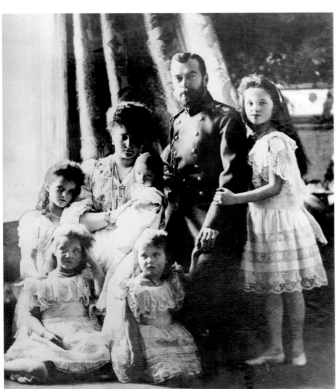

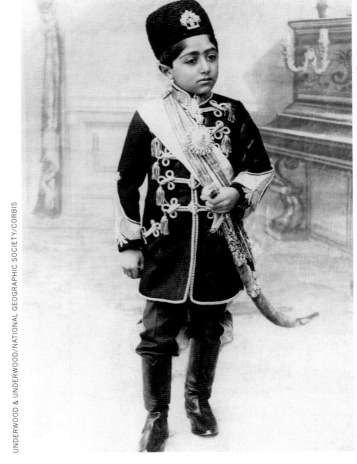

THE SADDEST STORY involving royal children: In 1918, the Bolsheviks killed the family of Czar Nicholas II. Opposite: Grand Duchess Maria Nikolaevna, daughter of Nicholas. Top left: Sister Tatiana in 1902. Above: The family, including famous Anastasia (seated on the floor at right). Top right: Circa 1906, the boy who will become Carol II, king of Romania, and his sister Elisabeth. At right, circa 1908: The crown prince of Persia. On the next pages: Wilhelm II, king of Prussia and emperor of Germany, with his family in 1912. These folks were related to both Victoria and the czar.

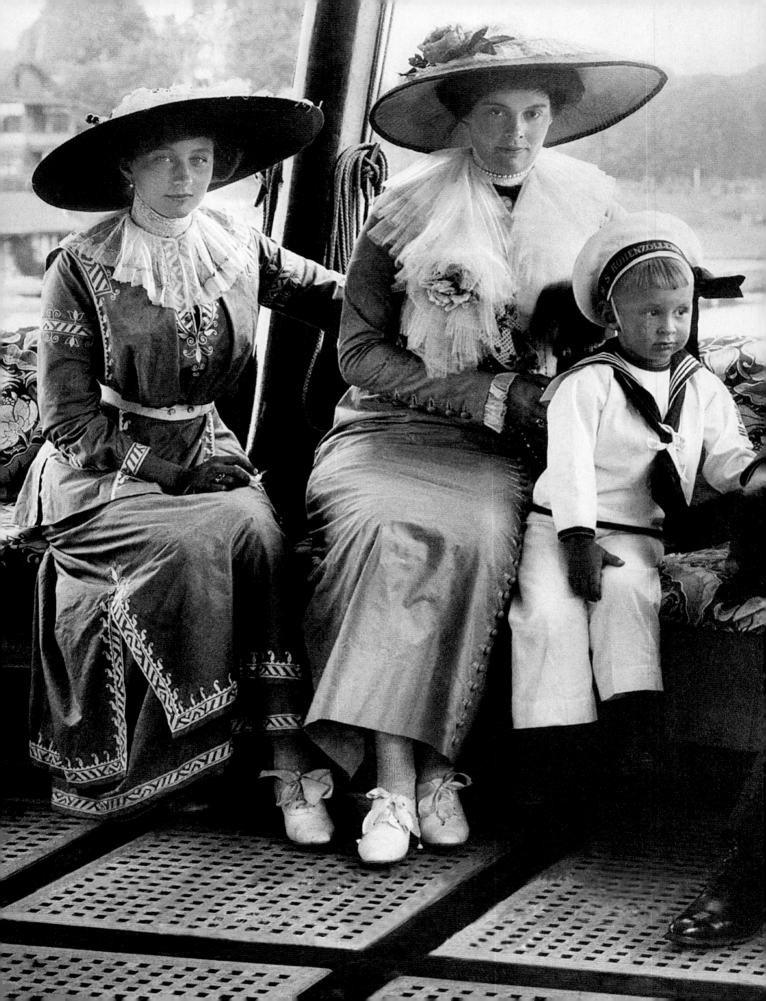

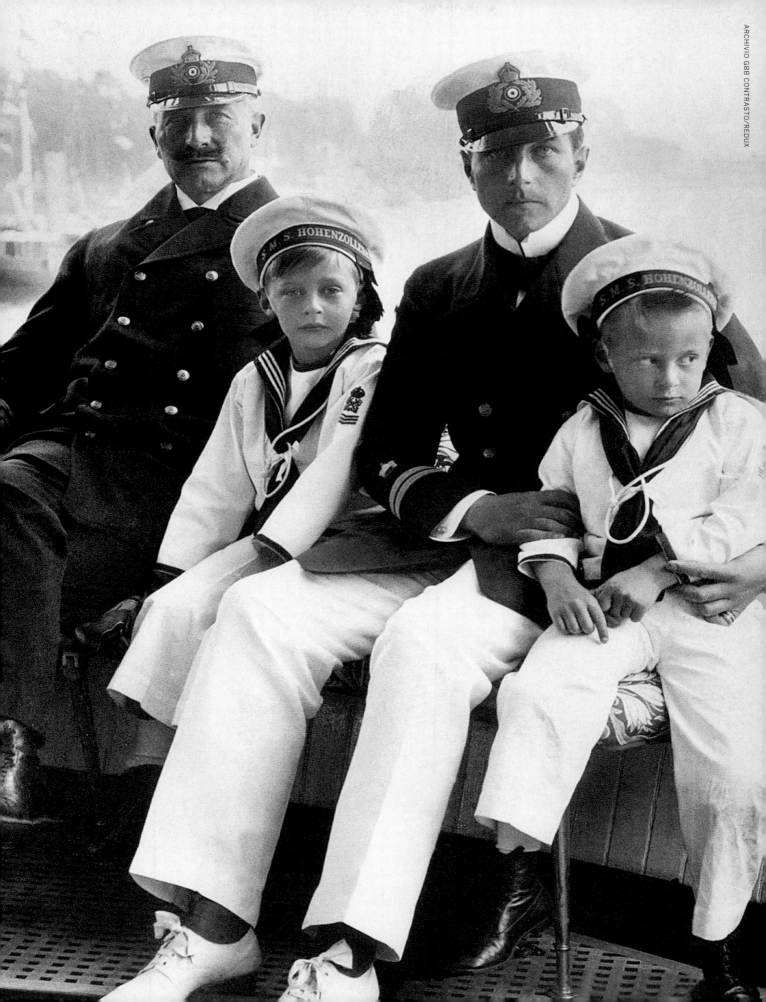

THIS PAGE, counterclockwise from top left: Circa 1905, the boy who, as Japan's Emperor Hirohito, will be enmeshed in the events of World War II; in 1973, Japan's five-year-old Princess Nori, daughter of Japan's Crown Prince Akihito and Crown Princess Michiko, wears a kimono given to her by her grandfather Hirohito; in 1939, the christening of the Prince of Siam; in 1922, Princess Yuan, said to be one of the prettiest of the children in China's royal family. Opposite, back in Tokyo in 1971: Prince Aya, Crown Princess Michiko and Princess Nori.

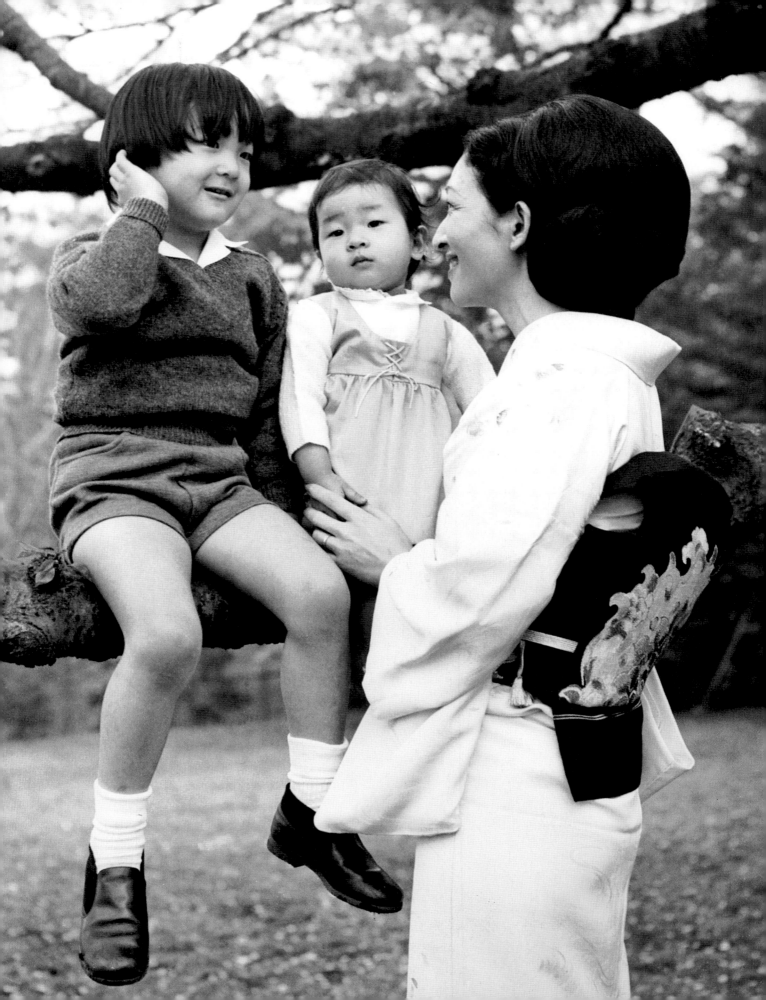

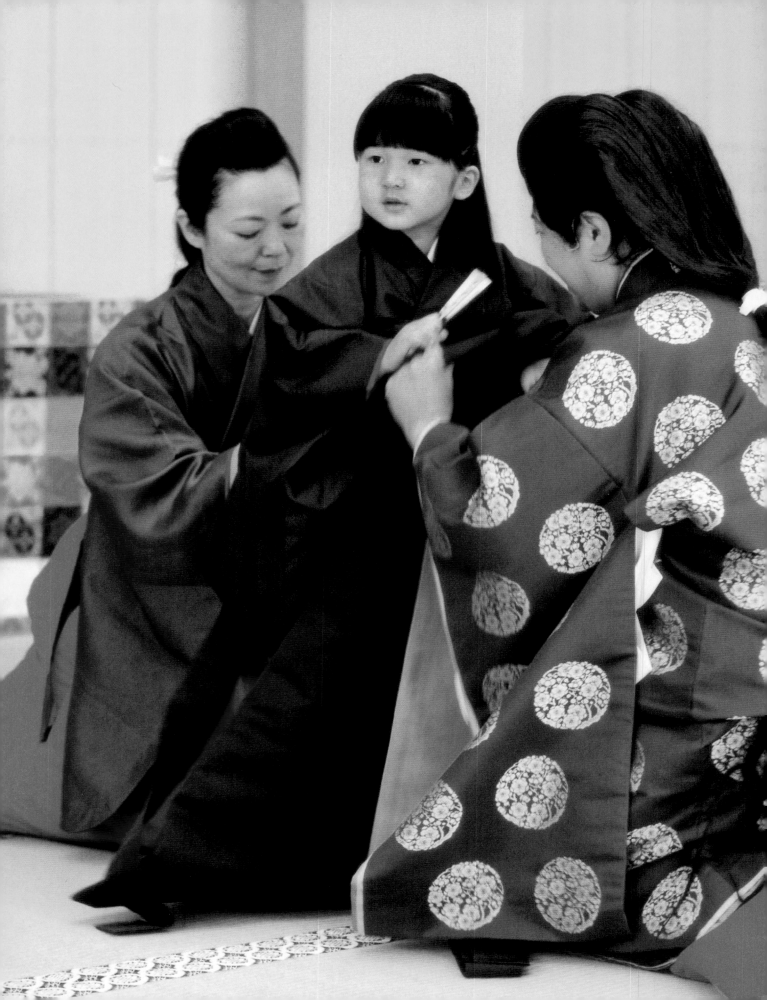

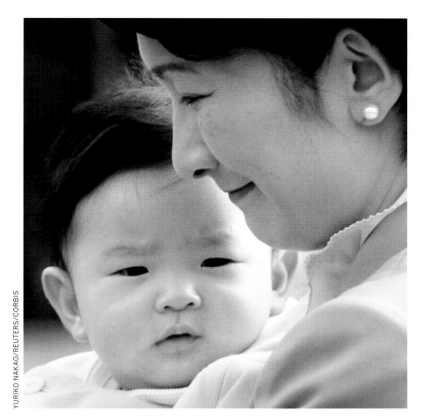

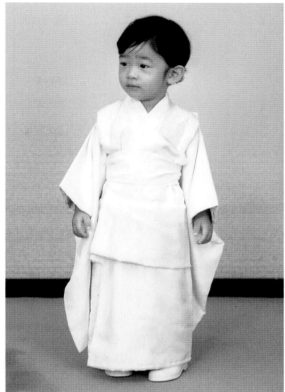

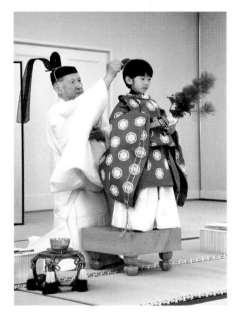

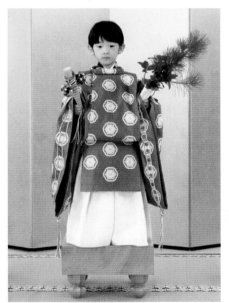

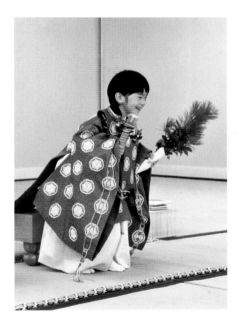

JAPAN, LIKE ENGLAND, is no longer ruled by a monarch, but it resolutely retains its monarchy; no other contemporary world powers behave quite like these two. Opposite: On November 7, 2006, Princess Aiko, daughter of Crown Prince Naruhito and Crown Princess Masako, who will turn five within a month, is prepared to rehearse the Chakko-no-gi ceremony at the family residence in Tokyo's Togu Palace. This page, top left: Princess Kiko, sister-in-law to Naruhito and Masako, with her son, Prince Hisahito, in March 2007. Top right: Hisahito a year later. Above: In November 2011, Hisahito again, now about to turn five himself, is captured by the camera three times during a rehearsal for the Fukasogi-no-gi ceremony at the Akasaka imperial estate in Tokyo.

BETTMANN/CORBIS

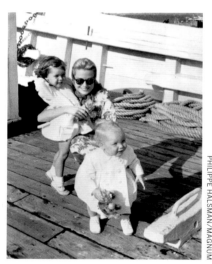

PHILIPPE HALSMAN/MAGNUM

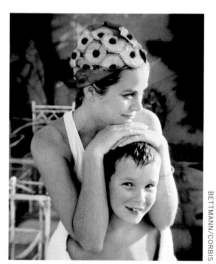

BETTMANN/CORBIS

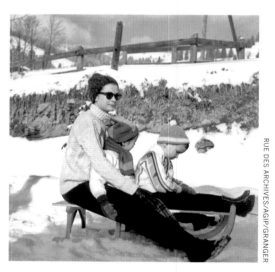

RUE DES ARCHIVES/AGIP/GRANGER

IN FASHIONING all of the pictures yet seen in these pages, even including those featuring Princess Diana, it was imperative that the photographer focus on the children. When shooting the kids born to Rainier III and Grace of Monaco in the late 1950s and early '60s, however, a shooter might have been shot if he or she returned to the office with any portraits not featuring the mother. So then, here: Five images featuring the lovely woman born in Philadelphia who is remembered today as both the film star Grace Kelly and as Princess Grace. At top, in Monaco on March 19, 1958, with her baby boy, five-day-old Prince Albert II. Above, left to right: Grace with her children, Albert and Caroline, in 1959; in Jamaica with nine-year old Albert in 1967; again with Caroline and Albert during yet another vacation, this one in Switzerland in 1963. Opposite: The trio in a color portrait made in 1959. You could have made a movie out of it.

PHILIPPE HALSMAN/MAGNUM

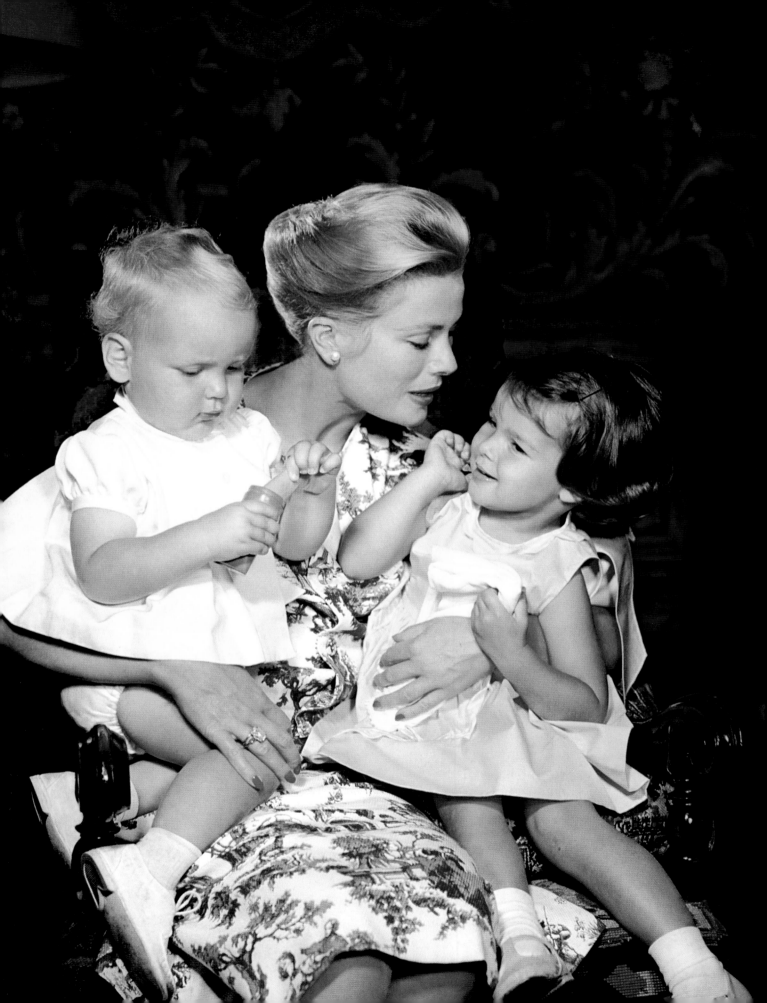

The Cambridges

ust as the world has waited for, and rooted for, the royal baby for the past several months, the world rooted for, and waited for Will and Kate for nearly 10 full years. From the first, because of their divergent backgrounds—he a royal, she, in the cruel parlance of the royal class, "a commoner"—theirs was the closest thing our contemporary society can provide to the Cinderella story. We came to care about them, and we wanted to see this thing through. Especially during the last third of their courtship, after they had taken time off in 2007 and then decided they were better together after all, their union seemed something like a necessity—at least it seemed like that for the monarchy, and for fans of the royal family. The recent past had been exceedingly ugly for the House of Windsor: sex, lies and audiotapes, a consuming fire at Windsor Castle during Elizabeth's annus horribilis, and then death itself: Diana's.

But here was the boy who might be king, grown to be a fine young man, and his too-good-to-be-true girlfriend, whose people had worked in the mines. They were both smart, they met in the modern way—at university. They seemed worth supporting, worth rooting for. The public became invested in this young woman in a way that had never happened before; she wasn't just the latest aristocrat plucked from the vine, she was from our team. Yes, this was a modern-dress telling of the fairy tale, minus the glass slipper and with the Palace's State Landau substituting for a pumpkin coach.

They had met in art class at the University of St. Andrews, and as early as the spring of 2001—a dozen years ago now—Will confided to friends that he was head over heels. For several years he tried to shield Kate, even following semiofficial dictums against holding hands in public. But in the current age, that is no use at all, as the couple were espied on Mediterranean vacations, hunting in Windsor Great Park, skiing in Zermatt. Kate, a super athlete, had been a fine skier since her girlhood, but no one had thought to photograph her skiing—until she was schussing with a prince on the slopes above Zermatt.

They seemed to be in love, and in 2008, having realized they couldn't live without each other, they seemed to say: Well, yes, we are in love, aren't we? They "came out" in a way they hadn't previously. The world sighed and smiled. And then the world asked, "So when are you tying the knot?"

Soon enough, was the unspoken answer.

SOON ENOUGH turns out to be April 29, 2011, at Westminster Abbey in London. Prince William's mother and father had engineered their own Wedding of the Century across town in St. Paul's on the other side of the millennial divide. Will and Kate walked their own, equally beautiful way.

46 A ROYAL BABY!

TOBY MELVILLE/REUTERS

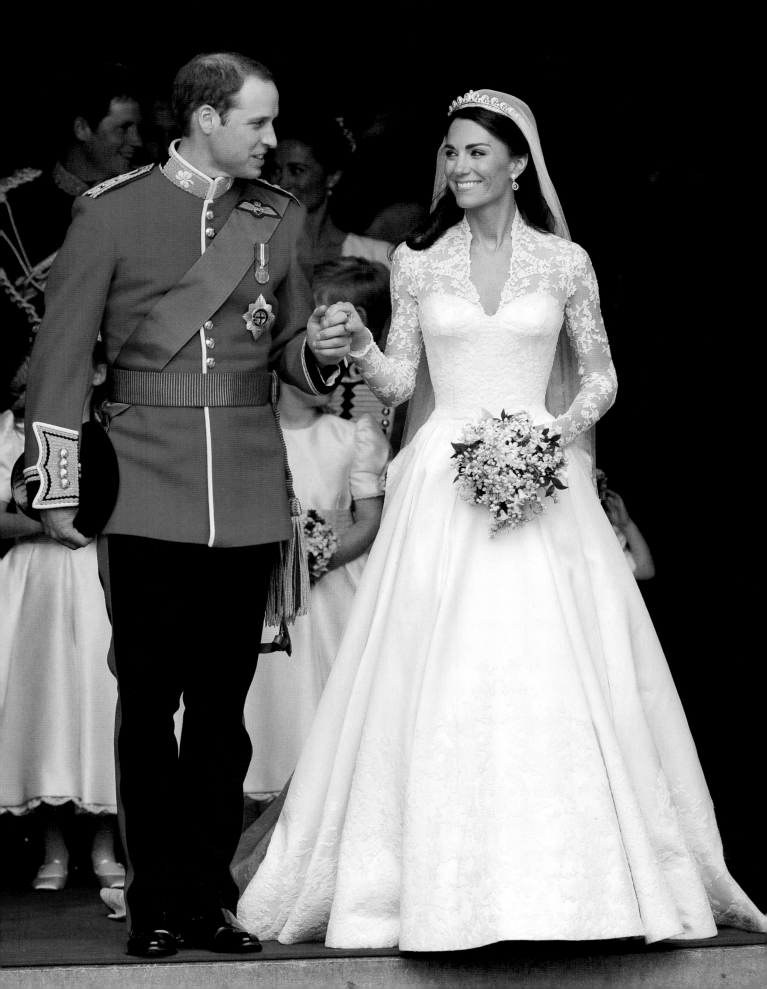

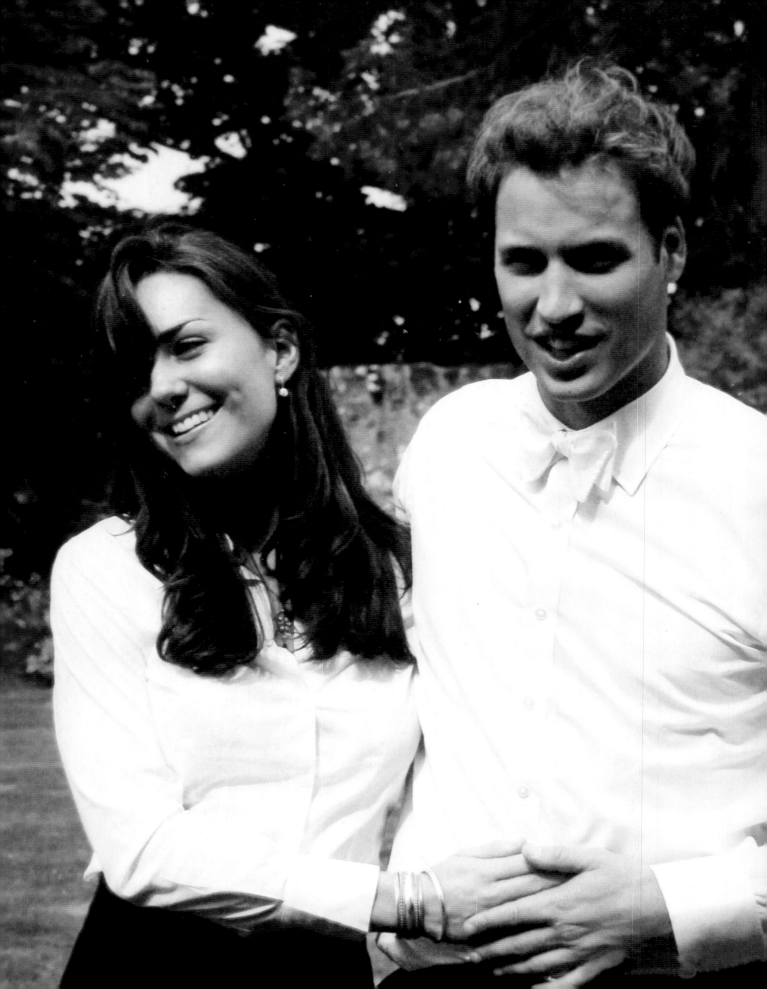

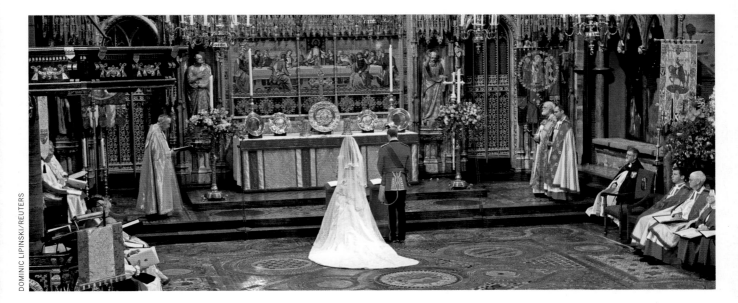

DOMINIC LIPINSKI/REUTERS

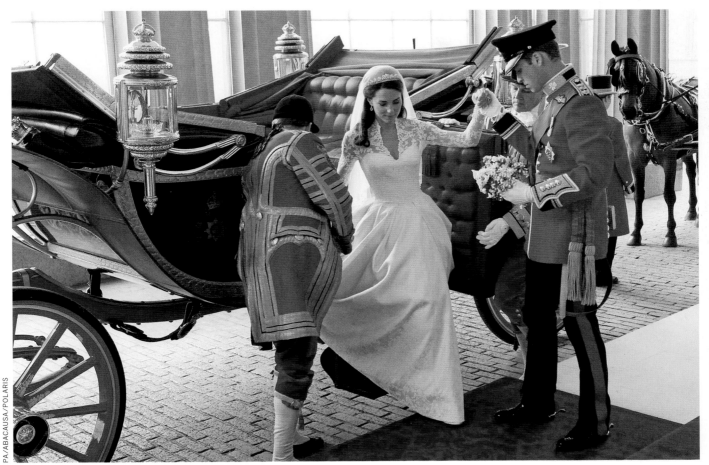

PA/ABACAUSA/POLARIS

THE MIDDLETON FAMILY/CLARENCE HOUSE/GETTY

COLLEGE KIDS (or, as the Brits would have it, university kids): Will and Kate are seen, on the opposite page, on the day of their mutual graduation from St. Andrews in Scotland on June 23, 2005. There are still shoals to be navigated in their relationship, but the happiness reflected here would prevail in the end, and in 2011 they are at the altar at Westminster Abbey (top). Later that day, the groom helps his bride from the State Landau upon their arrival at Buckingham Palace for festivities (above).

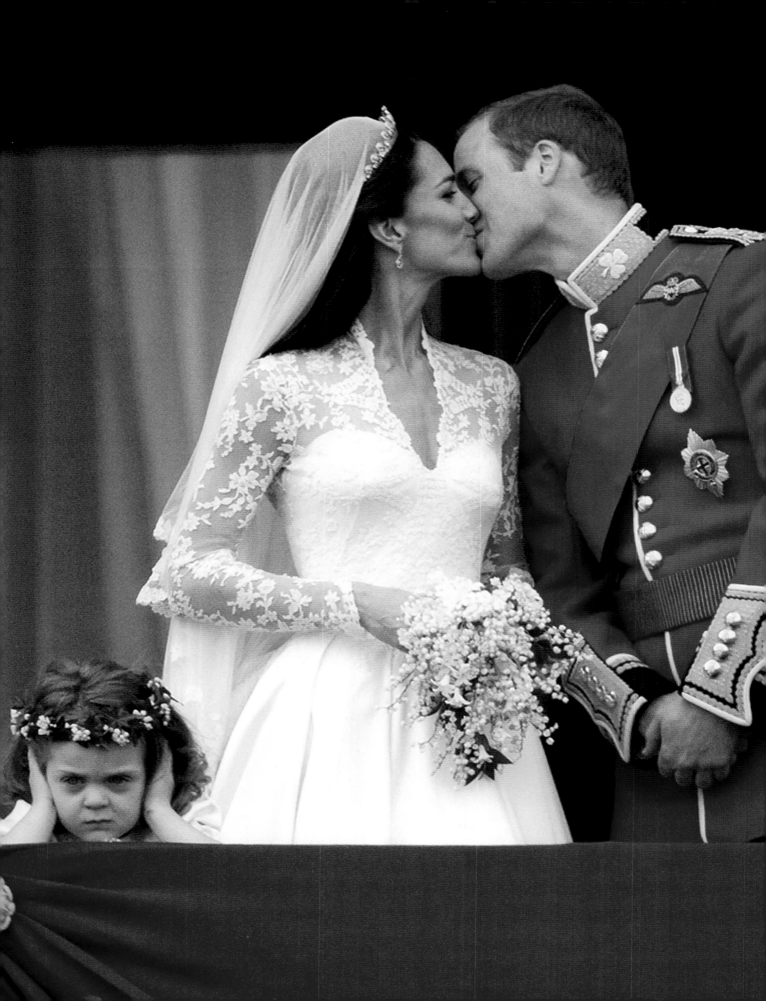

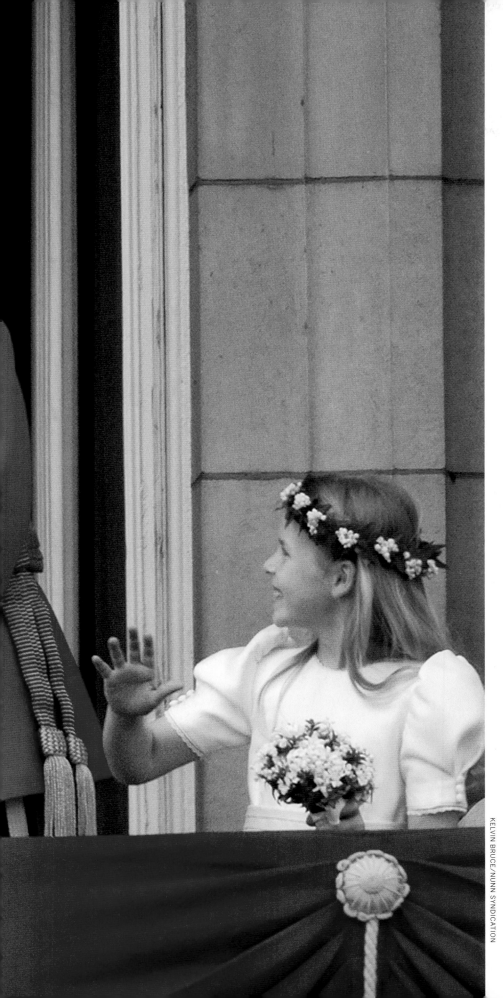

THE CROWD outside Buckingham Palace dwarfs all estimates and even astonishes the newlyweds when they step onto the balcony. Their countrymen have come for one thing and one thing only—the kiss. These folks in the throng certainly remember that Charles, years before, had seemed reluctant, and had required prodding by Diana before finally acceding with a Charlesian "Oh, well, yes, of course." Will and Kate are so different, and offer not one kiss for the people but a generous two. In this photograph, three-year-old bridesmaid Grace van Cutsem, William's goddaughter, covers her ears against the roar of the Battle of Britain ceremonial flyover. No one can or would ever blame her. It is all quite too much—the whole shebang—though the world loves it so.

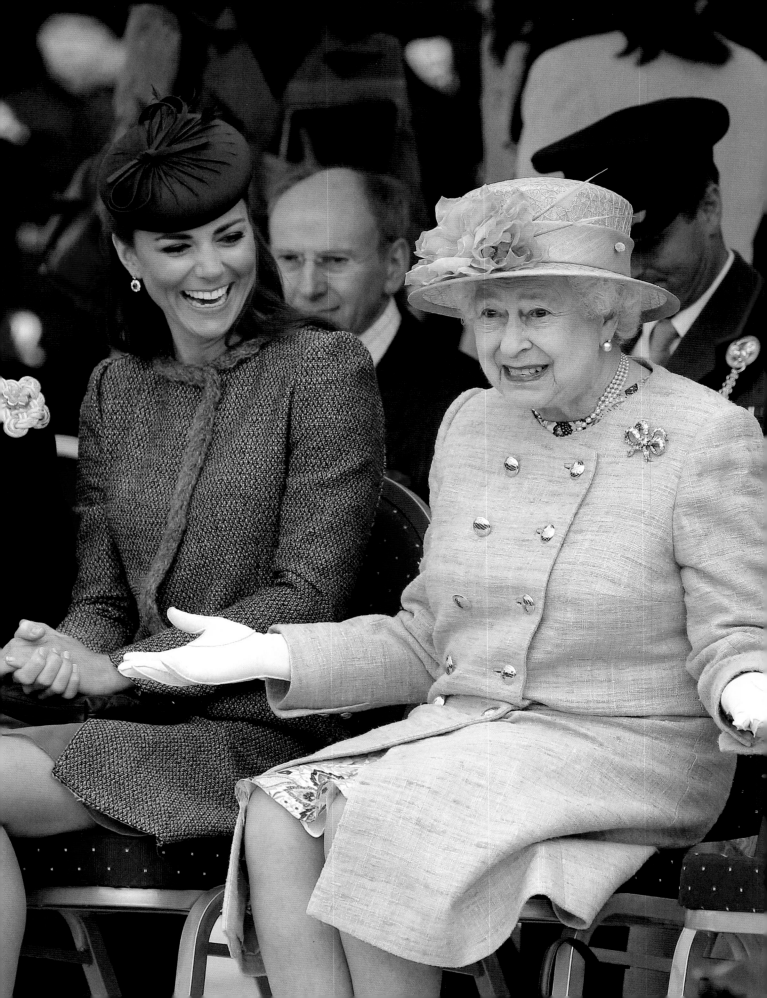

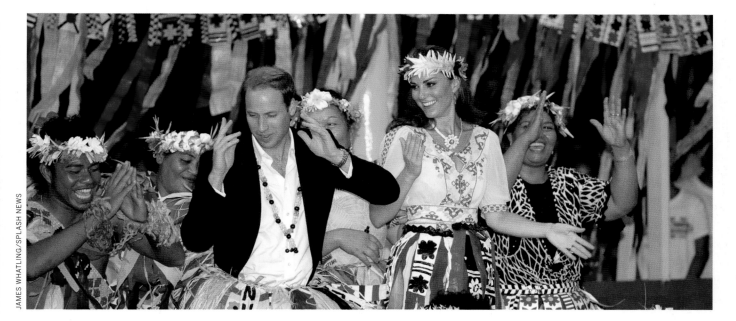

JAMES WHATLING/SPLASH NEWS

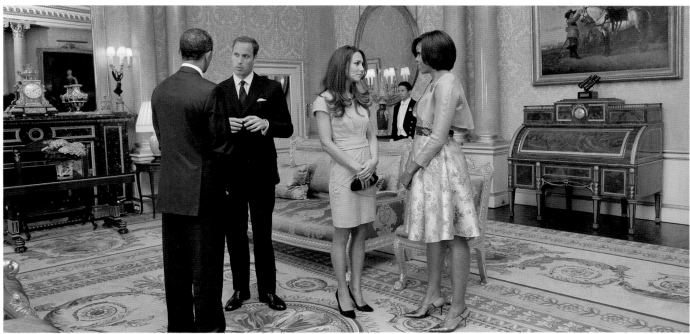

CAMERA PRESS/ROTA/REDUX

PRINCE WILLIAM OF WALES and Miss Catherine Middleton are bestowed a dukedom by the queen, and he becomes Duke of Cambridge, Earl of Strathearn and Baron Carrickfergus. Miss Middleton, upon marriage, becomes Her Royal Highness the Duchess of Cambridge, Countess of Strathearn and Lady Carrickfergus. This doesn't include a whole lot of unworkable responsibilities, but for both: It is a job, not least since the United Kingdom has no more attractive representatives than William and Kate. Clockwise from the opposite page: Kate laughs as her grandmother-in-law gestures during a children's sports event at Vernon Park in Nottingham, central England, on June 13, 2012; the Duke and Duchess of Cambridge dance while visiting the Polynesian U.K. satellite Tuvalu in September 2012; William and Kate hobnob with U.S. President Barack Obama and First Lady Michelle Obama at Buckingham Palace. At this moment in time, these are the world's two most glamorous couples—Posh and Becks, Brad and Angelina notwithstanding.

PHIL NOBLE/AFP/GETTY

XINHUA/GAMMA

HERE WE HAVE two final photographs just before the world—and the royal family—enters into pregnancy-watch mode. Opposite: In August 2012, they are the ultimate ambassadors to the Olympic community in London, and here they celebrate after Great Britain wins the men's team sprint cycling event in the Velodrome. Above: On September 15 of the same year the royal couple, who can't help but look great (or as if they're stepping forth in a Banana Republic or Bono-charity ad), are in Malaysia during a four-nation trip in Southeast Asia and the South Pacific on behalf of Queen Elizabeth II's Diamond Jubilee.

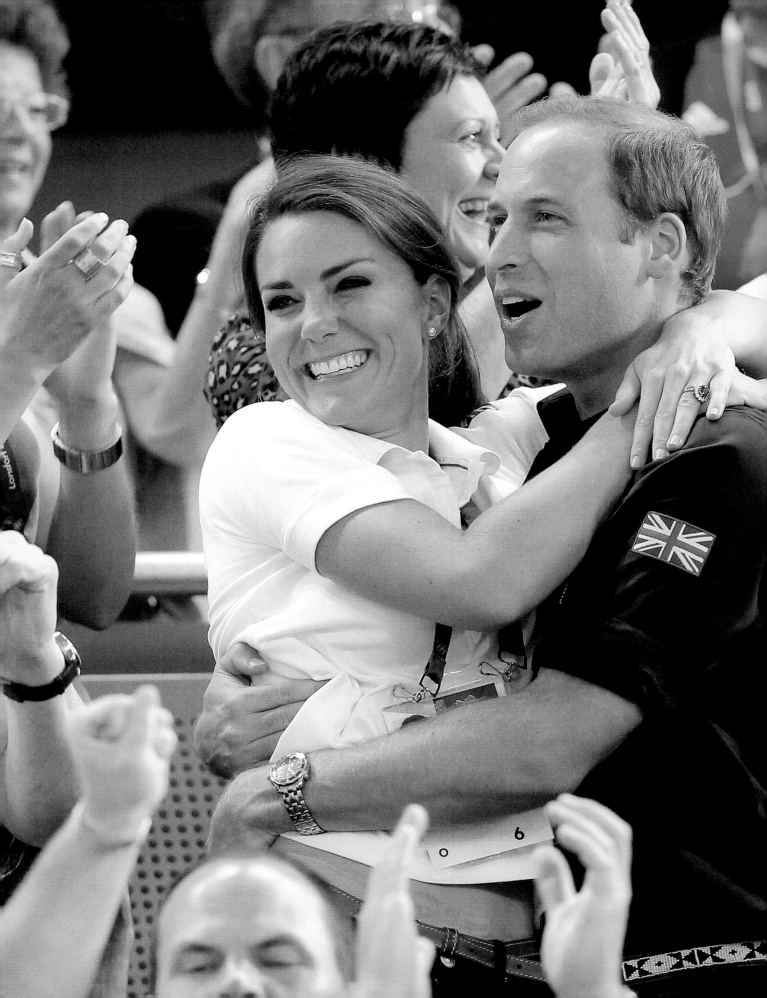

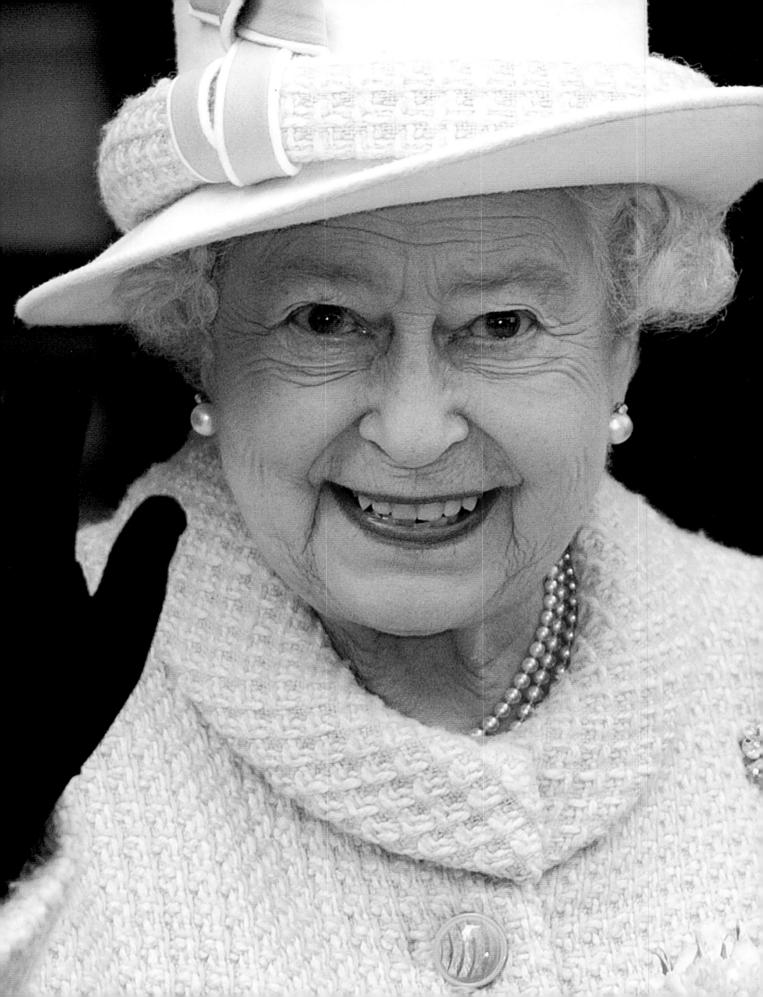

Her Majesty, the Great-Grandmum

Some of this we know but it's worth reviewing: Princess Elizabeth Alexandra Mary of the House of Windsor was born on April 21, 1926, to Prince Albert, Duke of York (the future King George VI) and the former Lady Elizabeth Bowes-Lyon. The delivery took place at the baby's maternal grandparents' home on Bruton Street in the fashionable Mayfair section of London. When the blessed event approached and then occurred, Elizabeth was "the royal baby" to whom everyone was paying attention. She was baptized, as is the case with all Windsors (now including Kate and William's child), into the Anglican Church—Elizabeth's ceremony being in a private chapel at Buckingham Palace. Her education and that of her sister, Princess Margaret, who joined the family in 1930, was overseen by the girls' mother and their governess Marion "Crawfie" Crawford. In other words: a bygone time, which will not apply to our new royal child.

Lilibet, as she was called around the house, was a good girl: studious, sensible and with a pronounced attitude of levelheadedness (precisely what is hoped for the newest—or any—royal). None other than Winston Churchill pronounced Elizabeth, after seeing the little girl when she was but two years old, a character. "She has an air of authority and reflectiveness astonishing in an infant."

Obviously, on the basis of more than eight further decades of evidence, that air has served her and her country well. Things got complicated in 1936 with the abdication of her father's brother, and suddenly she was set up as the monarch-to-be. She accepted that, accepted her role as an inspirational figure in World War II, and then in 1952, when her beloved father died, accepted the crown. Meantime, she fell in love with and married a handsome young gentleman, also of a royal family, Prince Philip of Greece and Denmark. Despite grumblings in Britain—some of Philip's relations had been cozy with Nazis—the lovers were devoted, and theirs has proved a durable union.

And Elizabeth has proved an exceedingly durable queen, an iron lady as strong and stoic as Margaret Thatcher or any other Britisher. She persevered through trivial and mortal travails with dignity, and then, in 2012, was celebrated by her countrymen for that effort during her Diamond Jubilee—a grand and grandiose fete to mark her 60th year on the throne.

Now, a year later, she enjoys a quieter but certainly no less resonant event: She becomes a great-grandmother once again (her grandson Peter Phillips—Princess Anne's son—has two children, Savannah and Isla). Whether, going forward, she pushes prams or hums lullabies we may never know. But with Elizabeth we can be certain: She will perform admirably.

QUEEN ELIZABETH in the City of London on December 13, 2012.

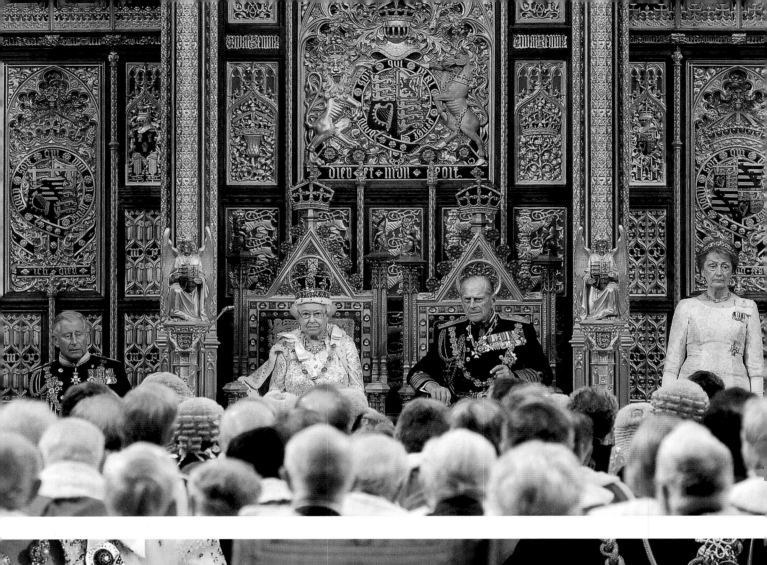

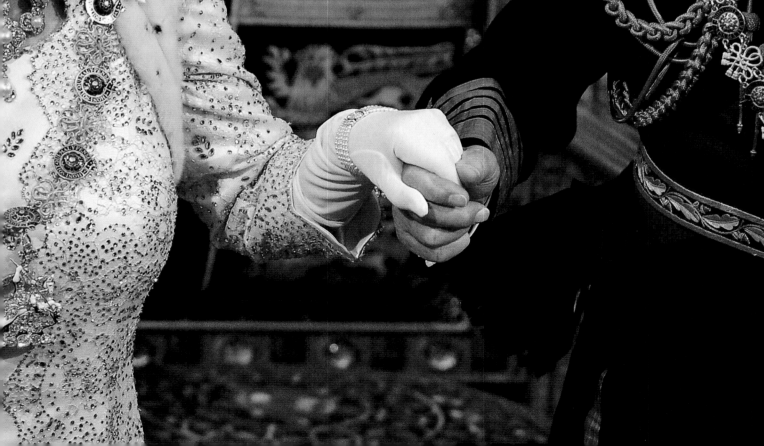

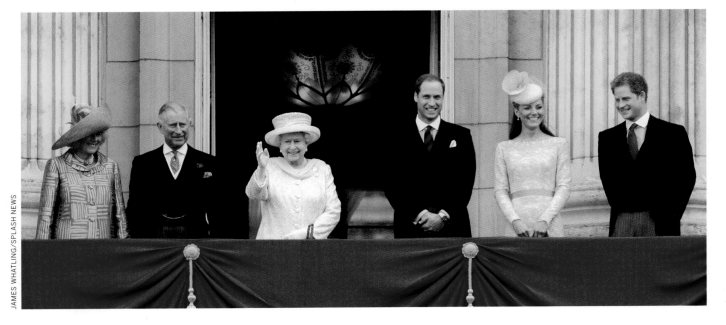

HER PUBLIC LIFE TODAY is one of constantly grand ceremony, and one must look closely to find what truly matters to Elizabeth. Clockwise from opposite page, top: She prepares to deliver her annual speech during the State Opening of Parliament at the House of Lords on May 8, 2013; she visits Dersingham Infant and Nursery School near her Sandringham home in Norfolk on the 60th anniversary of her father's death, the very day she became queen, thus marking the start of her Diamond Jubilee year in 2012; she is joined by Camilla, Duchess of Cornwall; Prince Charles; Prince William; Catherine, Duchess of Cambridge; and Prince Harry at Buckingham Palace during the Jubilee; she and her husband hold hands at the House of Lords opening.

BELOW: Only weeks before marrying in April 2011, Prince William of the Royal Air Force explains to his queen—and his grandmother—the intricacies of the Sea King search-and-rescue helicopter that he pilots. These Windsors are at RAF Valley in north Wales, where William is stationed and near where William and Kate settled before marrying. Right: Canadian prime minister Stephen Harper stands with Queen Elizabeth II as she unveils a portrait of herself in the White Drawing Room at Buckingham Palace on June 6, 2012. The painting was made by the Canadian artist Phil Richards.

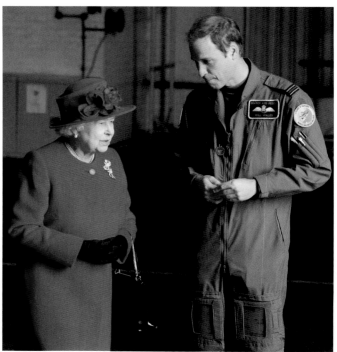

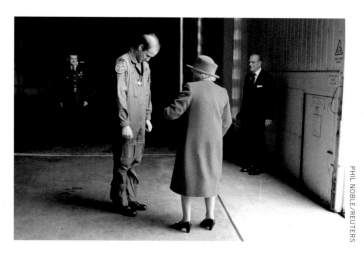

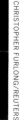

ROTA/CAMERA PRESS/REDUX

CHRISTOPHER FURLONG/REUTERS

PHIL NOBLE/REUTERS

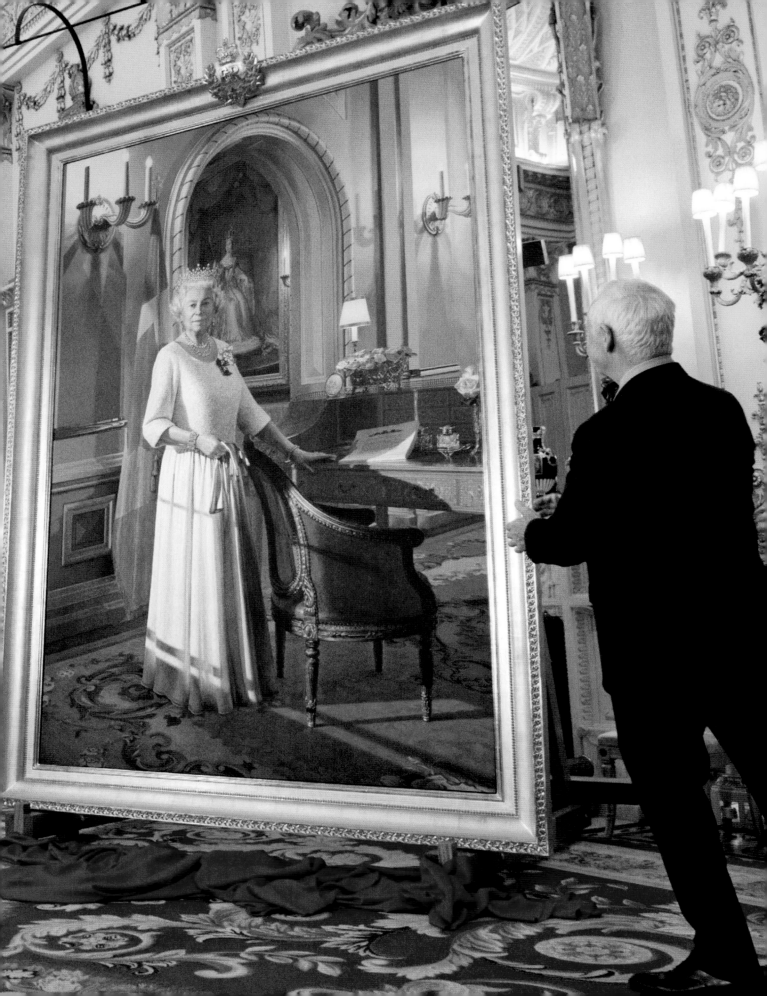

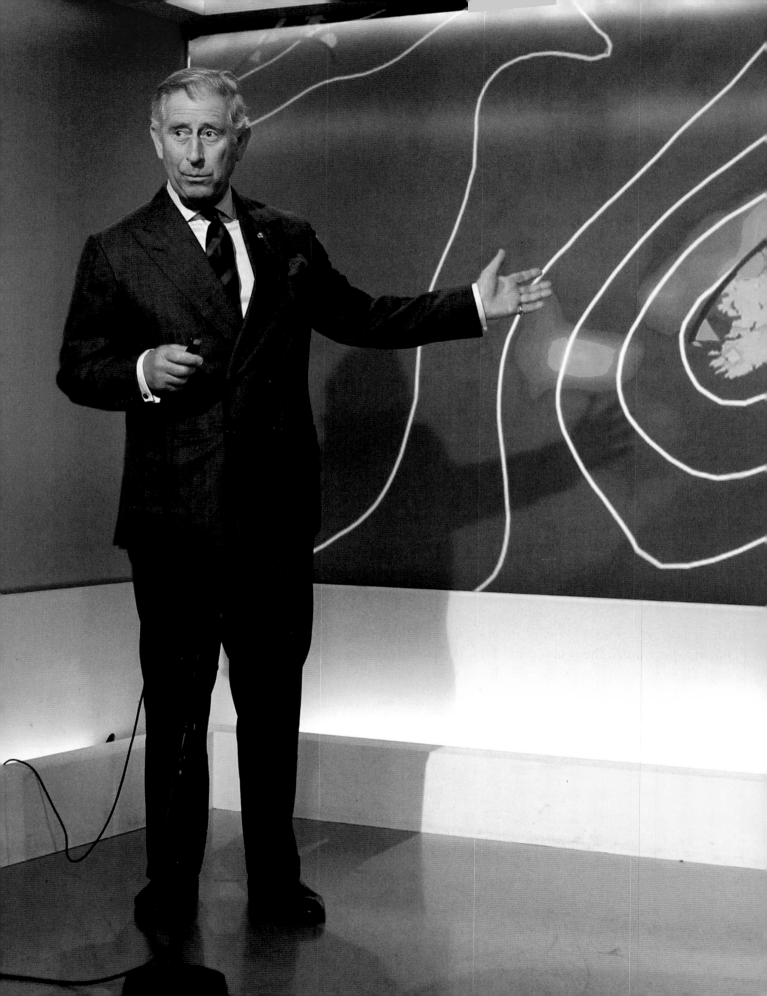

His Royal Highness, Granddad

The royal families who have run the course with the United Kingdom down the decades—down the centuries in fact, even down the millennia—have had more than their fair share of greats, gallants, goofballs, villains, mediocrities and eccentrics. Where in this broad range Prince Charles fits is hard to say. He is in no way a bad guy. He is also no national hero. He, like his mother, has weathered much, and how it has affected him is difficult for an outsider to assess. He was singular before he married, before he divorced, before his first wife died—and if he is singular still, who is to say what formed him? He is the heir apparent to the British throne. But the polls say that *some* of his countrymen, after having spent much the better part of a lifetime with Charles, would prefer that, in the event of the queen's death, Charles cede the throne to his son William. What will happen will happen (which has always been the modus operandi with Charles), but for now: He has become a grandfather, and

THE PRINCE OF WALES, always with oddball tendencies, has loosened up even further in recent years—and this latest Charles has played well with the proletariat. In May 2012 at BBC's Scottish headquarters in Glasgow, he describes for viewers a low-pressure area that is quite characteristically besetting the isles. He gets good reviews.

this only embellishes a role he has approached conscientiously for some time: that of William and Harry's dad.

He wasn't the parent most responsible for raising or forming the boys; Diana was. Palace watchers would have guessed as much. Charles had been a playboy, coached in the presumed prerogatives of a male royal by his great-uncle the legendary Lord Mountbatten. Then Charles married Diana on July 29, 1981, with 750 million worldwide witnesses, but he didn't develop a lot more seriousness of purpose. She was 20 and in over her head. He was 32 and doing his job. Dissatisfactions were immediate and they multiplied. But Diana gave birth to two boys before the marriage fell apart completely, and both Di and Charles were dedicated to the well-being of Wills and Harry. Then Diana died, and Charles became an even better father.

Part of the problem in his first marriage was his never forsaken love for Camilla Parker Bowles, who had married another, and now he and she (who meanwhile had been divorced from her husband) wed—in April 2005. Since then they have split their time between various splendid residences—Clarence House in London, Highgrove House in Gloucestershire, the Birkhall estate near the queen's Balmoral Castle in Scotland and Llwynywermod (say it three times, fast), an elaborate farmstead in Wales—and have by all accounts been very happy.

Now, Charles, a grandfather for the first time, is happier still.

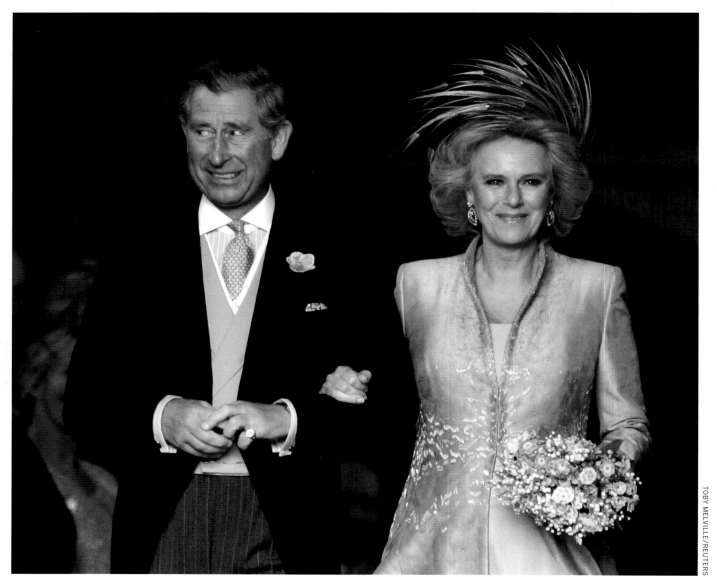

DYLAN MARTINEZ/REUTERS

TOBY MELVILLE/REUTERS

MICHAEL DUNLEA/AP

MARRIED MAN: Charles and Camilla, now Duchess of Cornwall, leave St. George's Chapel in Windsor Castle (above) after the Service of Prayer and Dedication following their marriage on April 9, 2005. At left, they converse during a visit to the old fort at Nizwa in northern Oman in March 2013. Military man: Charles salutes (opposite, top) alongside his sons, Harry and William, after the Sovereign's Parade at the Royal Military Academy Sandhurst on April 12, 2006; Harry has just graduated as an army officer. Opposite, bottom: In March 2008 the boys and their father leave the Royal Air Force base in Oxfordshire after Harry has returned home from Afghanistan. He was pulled from the front when news leaked out that he had been secretly fighting the Taliban and it was thought he might be particularly targeted.

LUKE MACGREGOR/REUTERS

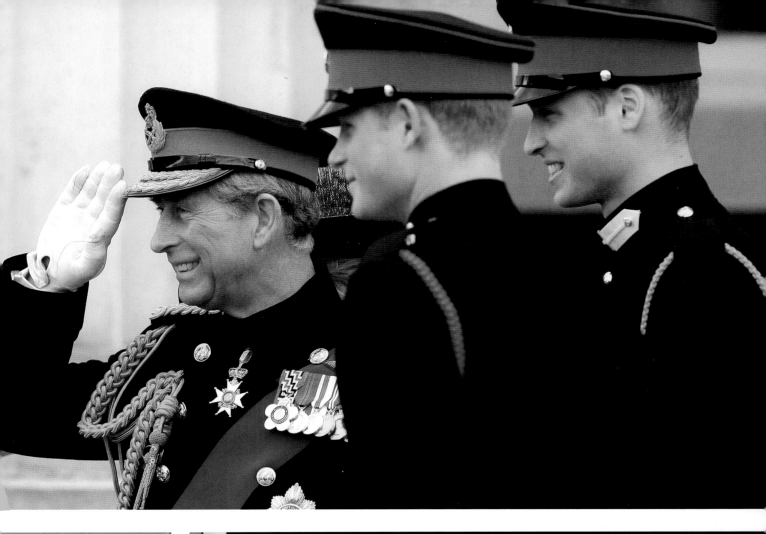
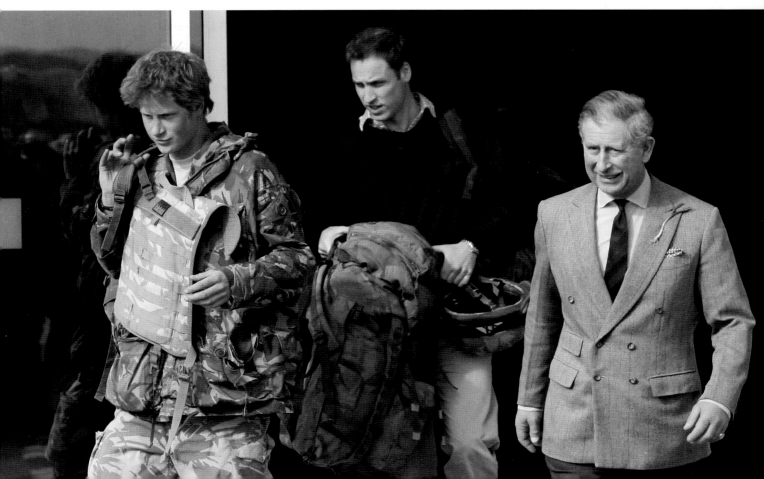

Uncles *and* Auntie

The royal baby has a Windsor uncle, a Middleton uncle, plus Aunt Pippa—which will certainly be the first name that any infant might choose to pronounce. We will start, here, with Harry.

He himself was "the royal baby" in 1984 when, two years after the birth of Wills, Diana and Charles welcomed a second son, who immediately became third in the line of succession behind his father and brother. Harry is more rambunctious and less studious than Wills, but his good nature and constant smile are infectious, and he has been popular—with all who know him and millions who don't—since his arrival. The boys have always been very close, and with their beloved mother's death they circled the wagons with their father.

As much as any Windsor, Diana included in the discussion, Harry has exhibited a dedication to duty and an obvious, instinctive sense of empathy. He is today a captain in the army, has served two tours in Afghanistan and is revered by those who serve alongside or under him. Just as an example: It was reported in June that several years ago in a training exercise, Harry stood up forcefully for a soldier who was gay and feared violence by other troopers. In Harry's other life, he has worked tirelessly on behalf of royal charities, traveling the globe and acting as a male Diana by meeting children on their level. Of course, women adore strong, sensitive men with warm, slightly devilish smiles, and it can be supposed that a World's Most Eligible Bachelor tournament might see in the final a Harry-versus–George Clooney matchup.

Highly seeded in the Sought After Female draw is Pippa Middleton, who enjoyed a star turn (impossible to steal the show, really) at the royal wedding in 2011. Whether Kate's kid sister is a career woman in the party-planning industry or that more amorphous designation "socialite" is your call. She is in some ways a female Harry—happy-go-lucky, a public figure of the first water, as the *Daily Mail* indicated when Will and Kate announced their engagement in late 2010: "Ironically, family friends of the Middletons say that everyone always thought that the sparkly Pippa rather than the quieter and less glossy Kate would be the one most likely to make a spectacular marriage."

James Middleton, a university dropout, has also done party planning, has enjoyed the limelight that has found his family and has not shown up evidently drunk in any paparazzi pictures since his sister became a princess. All good.

THE BEST MAN, Prince Harry, and the Maid of Honour, Philippa Middleton, walk down the aisle in Westminster Abbey, during the wedding ceremony of Prince William and Kate Middleton on April 29, 2011. Harry was already a star, and for Pippa, this day was quite a coming-out party on the world stage.

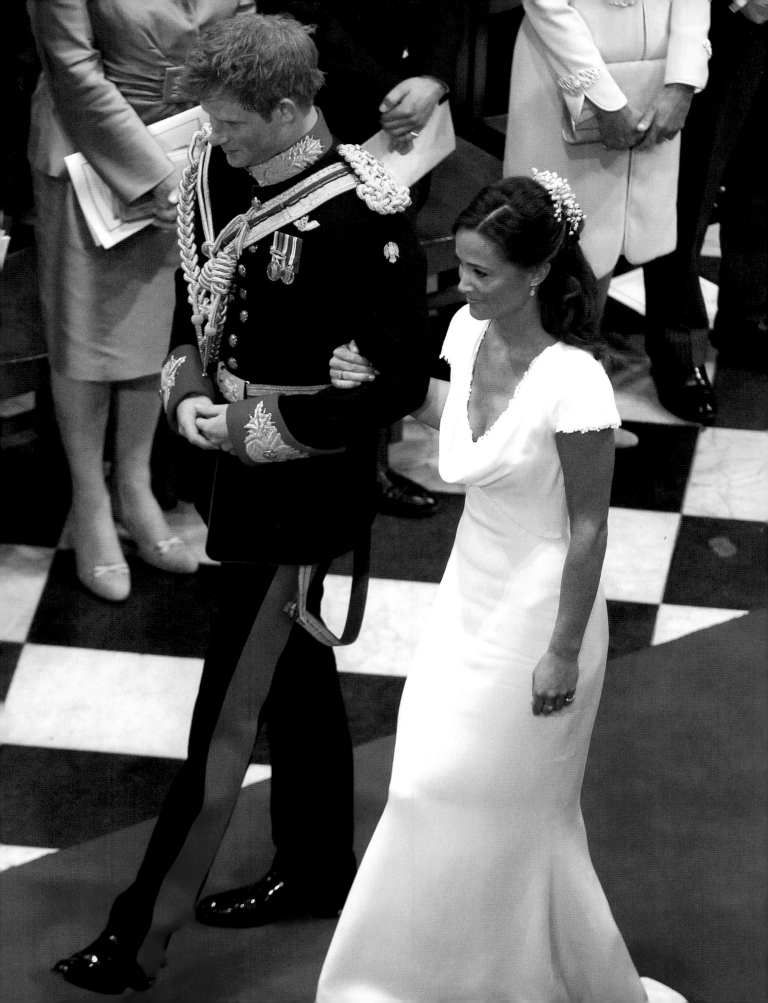

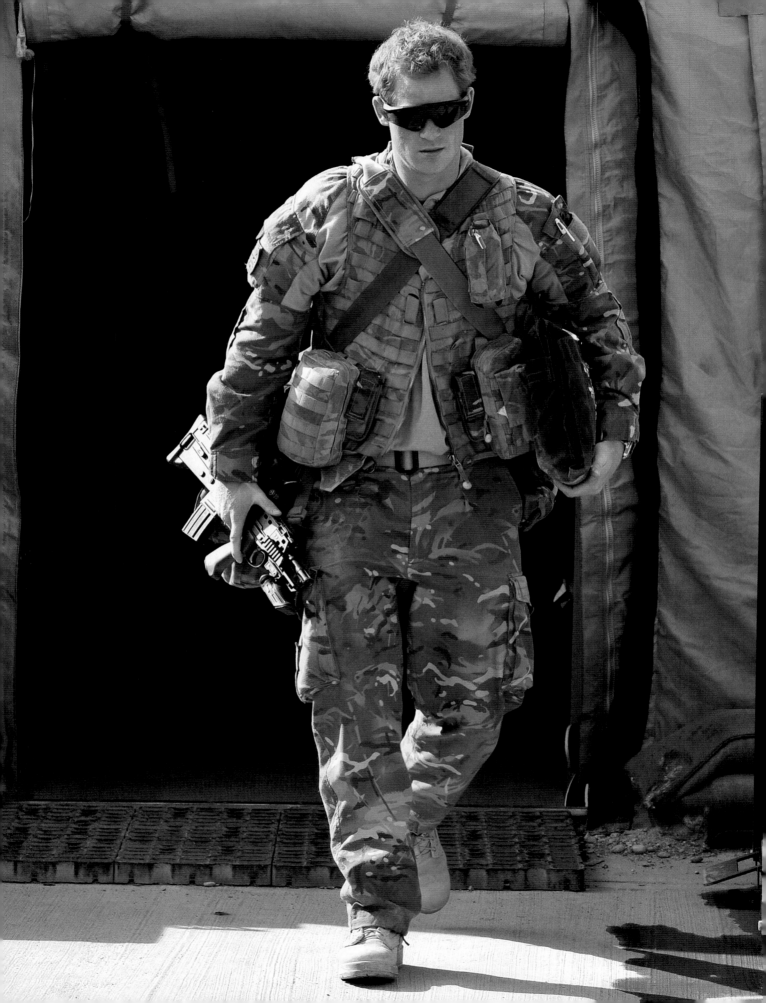

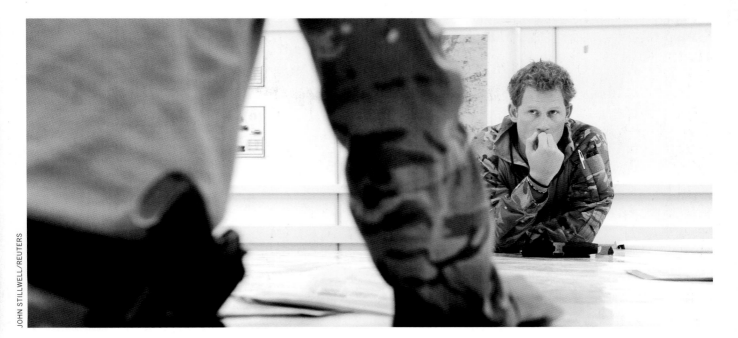

JOHN STILLWELL/REUTERS

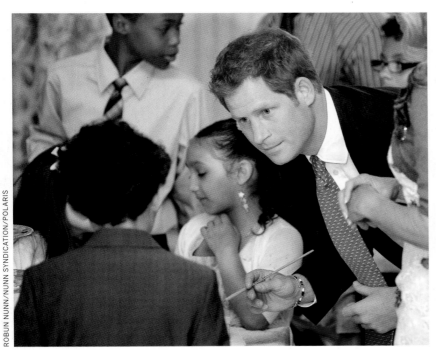

ROBIN NUNN/NUNN SYNDICATION/POLARIS

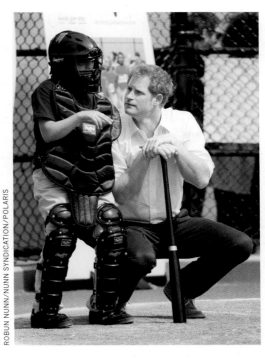

ROBIN NUNN/NUNN SYNDICATION/POLARIS

WE'RE JUST WILD ABOUT HARRY, and have been for a long time; he has whatever the English equivalent of je ne sais quoi is, and has it in spades. He's fun, frisky, handsome—and seemingly brave, clean and reverent. Opposite: Walking in Camp Bastion in southern Afghanistan in October 2012; he is serving there as a pilot/ gunner with the 662 Squadron Army Air Corps. On this page, counterclockwise from top: Harry attends a mission briefing in Camp Bastion; in the spring of 2013, he is at the White House in Washington, D.C., talking with children who are making presents for their mothers, who are serving in the military; during the same U.S. tour to raise money for charities, he is in New York City on May 15, pitching in at a ball field in New York City and announcing a partnership between Harlem RBI and the Royal Foundation of the Duke and Duchess of Cambridge and Prince Harry.

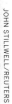

JOHN STILLWELL/REUTERS

IN THE POST-MODERN WAY, superstar Pippa has recently been signed by Vanity Fair *magazine to write about her family's love of tennis and, in particular, the Wimbledon championships (top, with brother James taking in the action at Center Court in June 2012). Above: On May 30, 2013, Harry arrives at the Walking with the Wounded charity's Crystal Ball gala at the Grosvenor House Hotel in London. Opposite: The brothers have always stood up for each other and certainly always will. Here they arrive together at Westminster Abbey on William's special day, when he will wed Kate.*

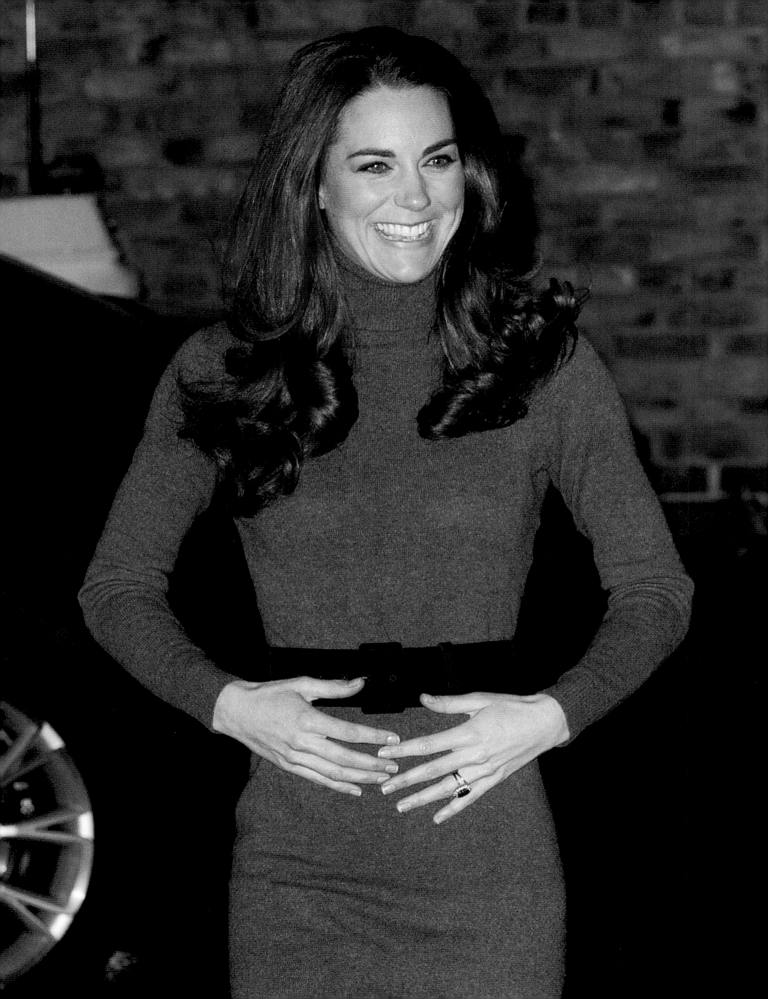

The World Awaits

STEPHEN LOCK/I-IMAGES/POLARIS

*W*hen it comes to royal weddings and royal babies, we Americans live vicariously through our cousins across the pond. All but one of our Presidents have come to us pre-wed, and we haven't had White House pregnancies since Jacqueline Kennedy's in the early 1960s (John Jr. was born between the election and the inauguration in 1960, but Jackie's pregnancy with the boy who would be named Patrick and who would die of a respiratory ailment after only two days of fragile infancy in the summer of 1963 was certainly monitored by an anxious public).

The good news is, as our pages have already shown, the British do these things well, do them big and do them graciously at regular intervals for all of us in the audience.

Even in the United Kingdom, there are royal weddings and then there are Royal Weddings; there are royal babies and then there are babies who leap to a high single-digit seeding in the line of succession the instant that they burble and drool.

ON DECEMBER 3, 2012, Buckingham Palace announces that, indeed, the Cambridges are expecting. There is no longer any hiding it, except that for a goodly while Kate hides it really well—at least physically. Here, three weeks after the public disclosure, she arrives at a charity for the homeless at Centrepoint, in London.

Fergie and Andrew's was a royal wedding and theirs were royal babies, but who would claim that any of that action held a candle to Charles and Di's, or the births of Wills and Harry, or the nuptials of Will and Kate. And now this!

So as soon as it was rumored (and it was falsely rumored several times for many months before the rumors finally proved true) that Kate was, as they indelicately phrase it over there, "preggers," everyone started to go bonkers and say things like "blimey," and the Fleet Street tabs (not to mention all the glossies globally) began an eight-month campaign that would very hopefully have its denouement in a healthy and happy baby and mom. That this fine conclusion has indeed been reached now causes us all to smile. Also, now, we can admit to how much we enjoyed the run-up.

As for Kate, she seemed to enjoy it too. She didn't say so, to be sure—the royals don't make casual comments any more, and there are no secret tapes any longer; *statements* are *issued*—but she looked happy in public. There was a terribly sad occurrence in the early weeks of the pregnancy when a media incursion caused great distress at a hospital where Kate was being treated while suffering morning sickness, and a young woman took her own life. The royal family was surely reminded anew about the scrutiny and consequence of everything that any one of them, or anyone around them, does or says. Will and Kate—especially Kate—carried on. And then in the early summer . . .

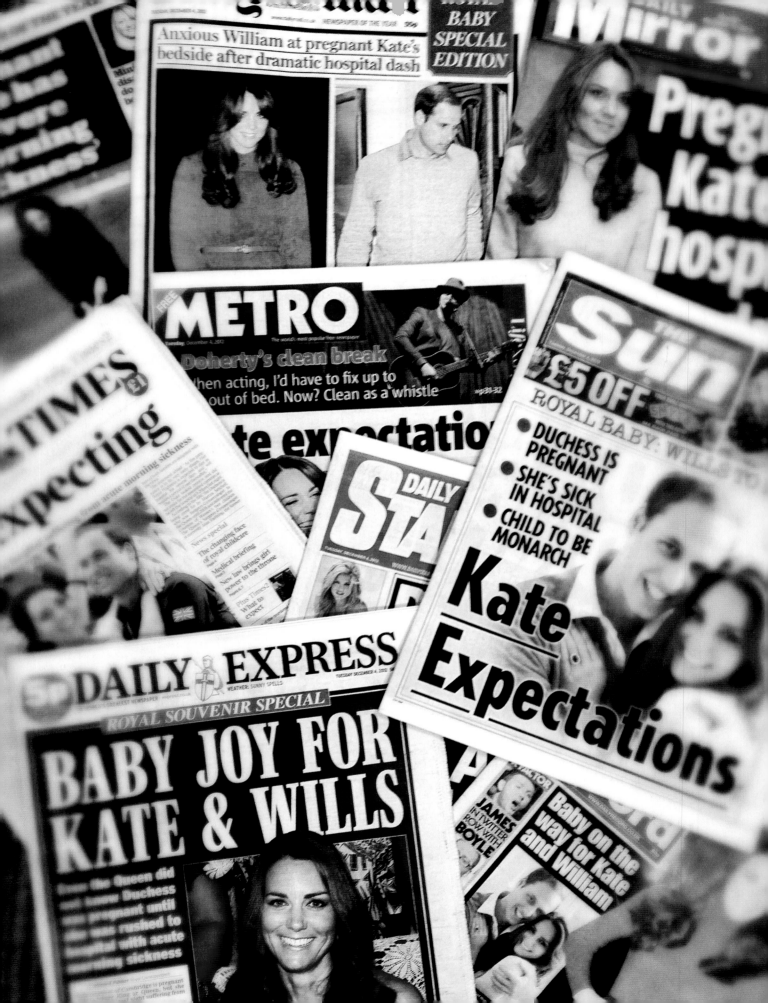

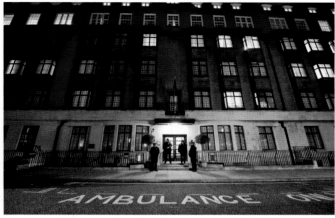

MAX NASH/PA/ABACAUSA/POLARIS

KI PRICE/EYEVINE/REDUX

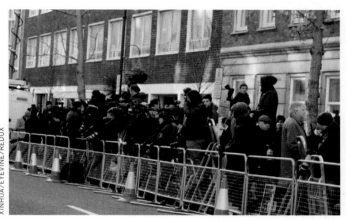

XINHUA/EYEVINE/REDUX

THE PALACE *says that it's true (statement below, right), and Fleet Street responds with more color and less decorum (opposite). Certainly one reason the Palace was forthcoming is that Kate was receiving medical attention, and this was going to leak out anyway. Above, left and right: King Edward VII's Hospital in London, where the Duchess of Cambridge has been admitted during the first week of December for treatment of hyperemesis gravidarum, a severe form of morning sickness, and she and her husband leaving the hospital on the 6th after a three-day stay. Right: The media scrum outside the hospital. Below: Tragedy. At left are the two Australian radio DJ's, Michael Christian and Mel Greig, who, by way of a hoax phone call to the hospital, were given news of the duchess's condition. Nurse Jacintha Saldanha, who put the call through to the proper authorities, is so remorseful that she commits suicide. At right is Saldanha's husband flanked by her children after a memorial service in London on December 15.*

ST JAMES'S PALACE

3rd December, 2012

THE DUKE AND DUCHESS OF CAMBRIDGE ARE EXPECTING A BABY

Their Royal Highnesses The Duke and Duchess of Cambridge are very pleased to announce that The Duchess of Cambridge is expecting a baby.

The Queen, The Duke of Edinburgh, The Prince of Wales, The Duchess of Cornwall and Prince Harry and members of both families are delighted with the news.

STEPHEN LOCK/I-IMAGES/POLARIS

CHANNEL NINE/AP

SANG TAN/AP

EDWARD SMITH/EMPICS ENTERTAINMENT/ABACAUSA/POLARIS

BY EARLY 2013, Kate is feeling much better and is still active, even as critics, wondering at the due date (which the Palace has not yet confirmed), speculate that she shouldn't have been taking swipes at field hockey balls the previous November. In the photograph above: In her role as a patron of Action on Addiction, she visits Hope House in Chiswick, London, on February 19. Opposite: A month later she is at the Great Tower Scout Camp at Newby Bridge in Cumbria, northern England. On the pages immediately following: She and William pose for an official photograph during a St. Patrick's Day Parade at Mons Barracks in Aldershot, southern England, on March 17. Prince William attends as Colonel of the Regiment, and on this day Catherine presents sprigs of shamrocks to the men, resplendent in red.

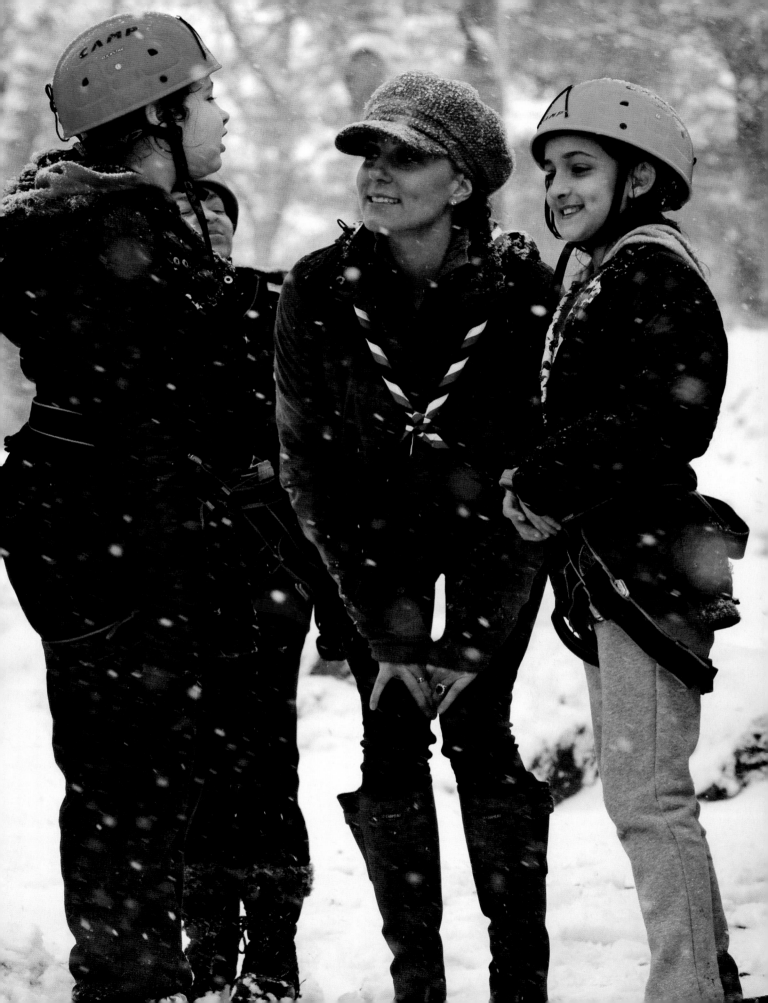

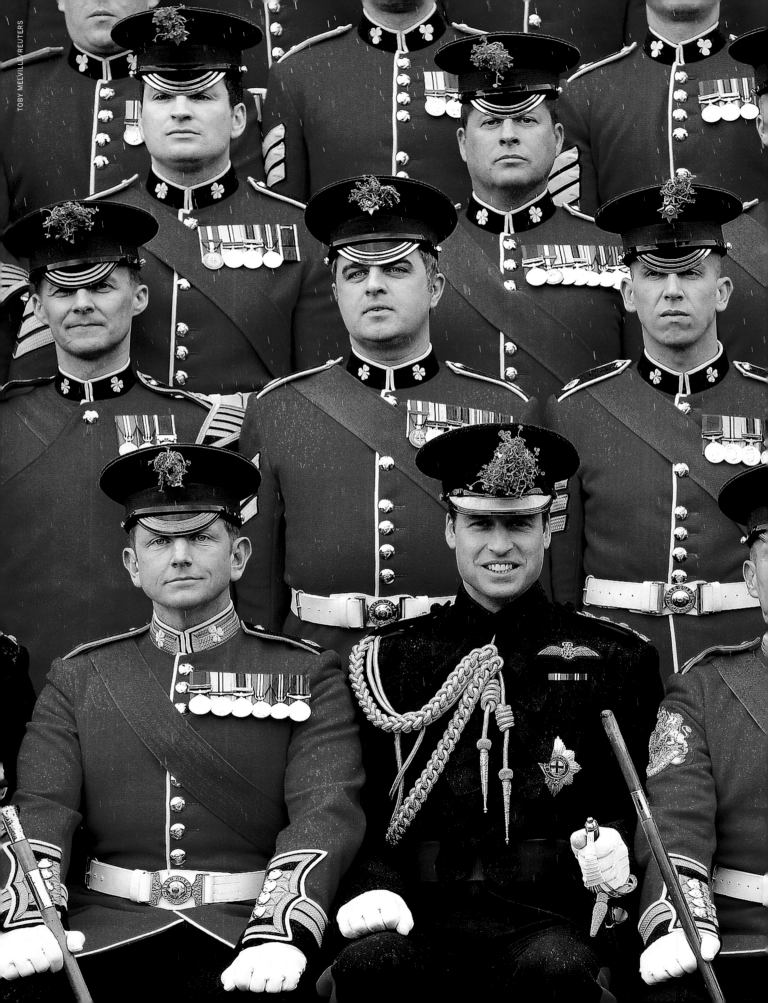

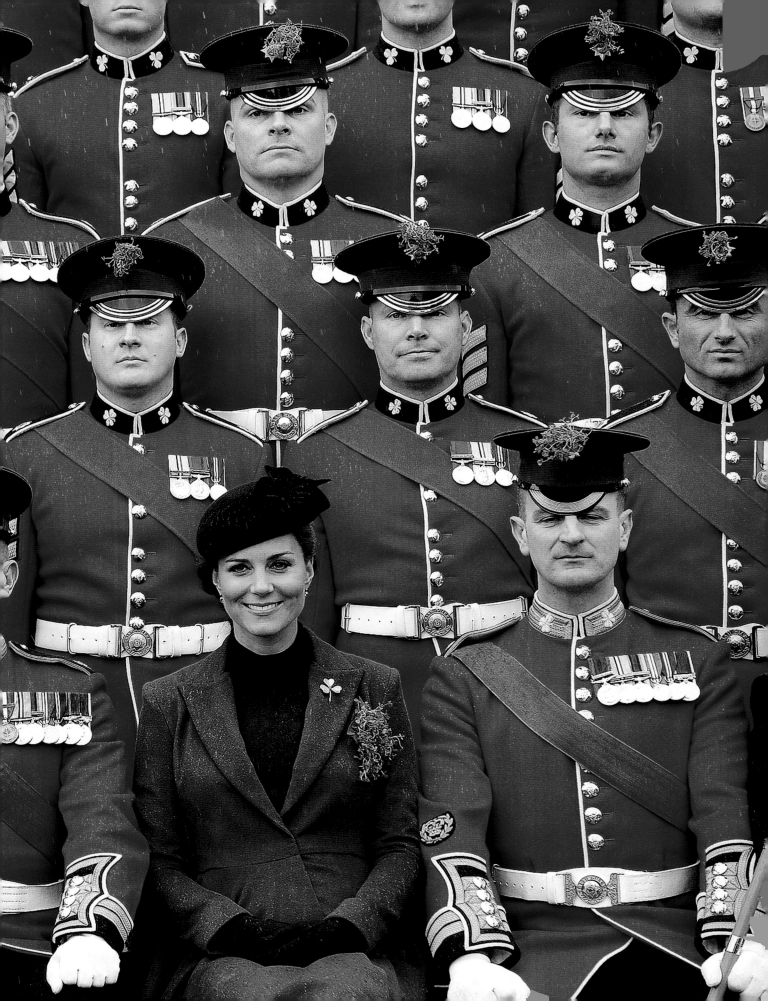

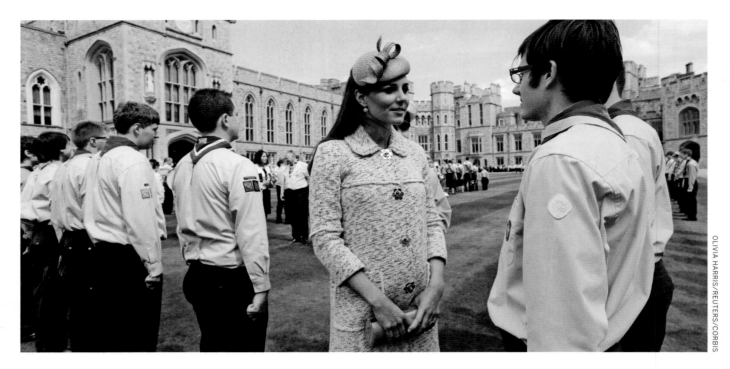

OLIVIA HARRIS/REUTERS/CORBIS

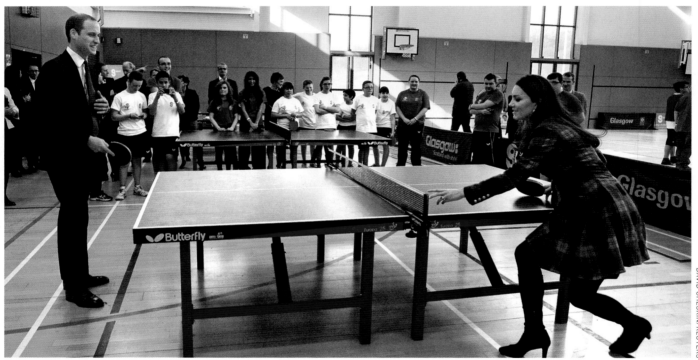

DAVID CHESKIN/REUTERS

OKAY, what to say about the pictures on the next several pages? Not a lot happens, but they are uniformly fun and lovely images, and remind us what an interesting thing this was: a pregnancy publicly shared. Not that it was carried out for our benefit, but at times it undoubtedly lifted our spirits. At top: More scouts, these during the National Review of Queen's Scouts at Windsor Castle on April 21. Above: A family table tennis match during a visit to the Donald Dewar Leisure Centre in Glasgow that same month. Opposite: Also in April, Kate is presented with a posy of flowers by Sally Evans as the duchess visits the Naomi House Children's Hospice in Hampshire to celebrate Children's Hospice Week. This particular day, April 29, is Will and Kate's second wedding anniversary.

MAX MUMBY/INDIGO/GETTY

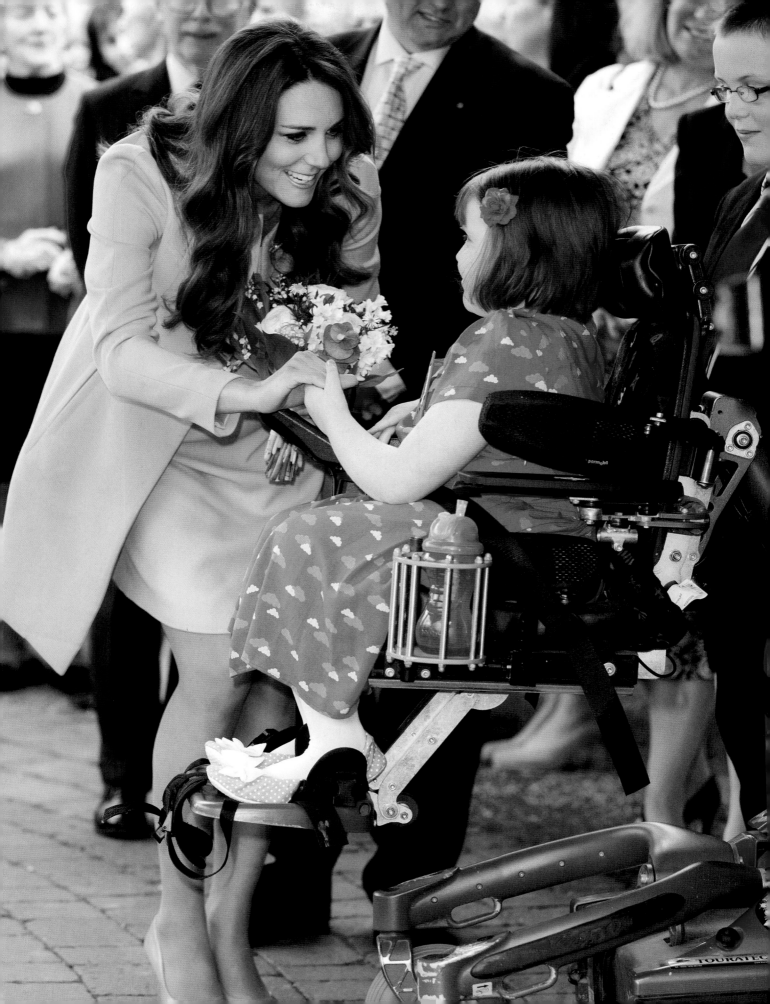

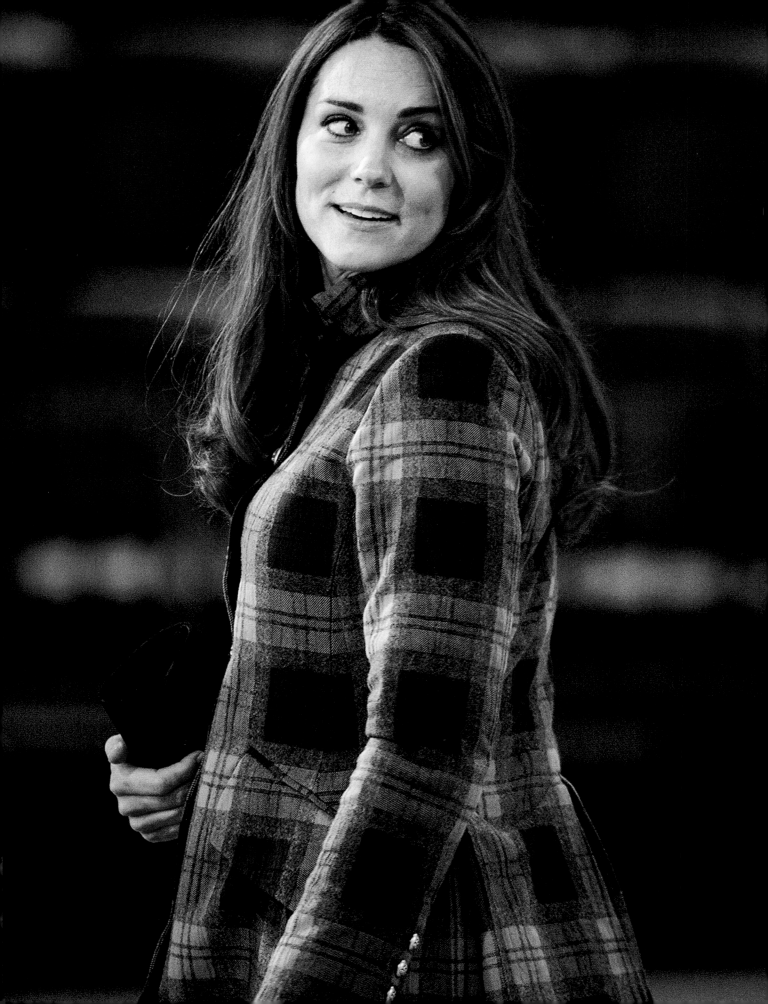

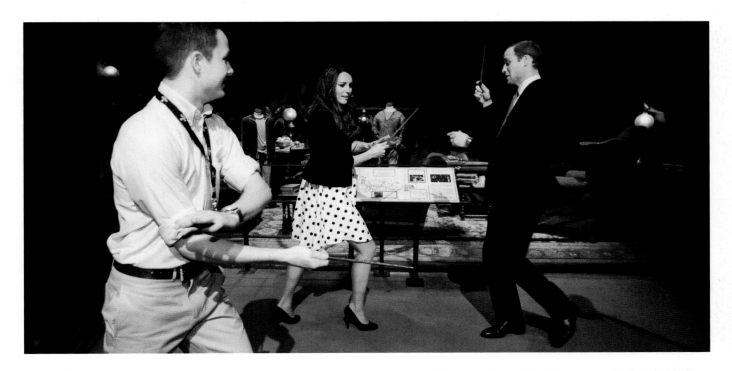

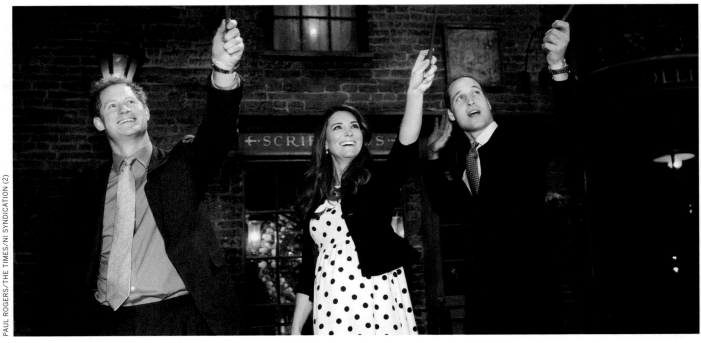

BY APRIL, everyone's paying attention. The bookies in London have posted their odds: Diana and Elizabeth (Kate's middle name and, of course, that of Her Majesty the Queen) are favorites for a girl's name, and the money's on George or Charles if it's a boy. Kate, for her part, is said to be shopping for nursery items for Kensington Palace, eyeing a move there in early autumn. Meantime, she is still around and about. Opposite is Kate, finally clearly with child, during a visit with her husband to the Emirates Arena in Glasgow on April 4. On this page: Two photographs from April 26 as the Cambridges boost Warner Bros. Studios in Leavesden outside London, where the Harry Potter films were made and where tourists now have the run of the place. In the photograph at bottom, wands in hand, they are joined by Prince Harry in issuing what is surely not a curse but a blessing.

SHE CERTAINLY plays her part for the maternity-clothes industry; not a week goes by in the spring of 2013 that she doesn't sport a brand new dress or coat. Just as the term preggers *isn't our thing, we're not that keen on* baby bump, *and have refrained from using it much until now—but, well, some things are no longer to be ignored. The latest from "reliable sources" is that Kate is eating more carbs, reading child-care manuals and growing ever closer to her husband—quite the usual when expecting your first child, it seems. Except nothing's usual when you're a princess. The garden parties you attend, like this one on May 22, are, for instance, sometimes at Buckingham Palace. In the photograph opposite, Kate's pretty hat, called a Fascinator and held in place God knows how, is overwhelmed by that of her father-in-law's wife, Camilla, Duchess of Cornwall.*

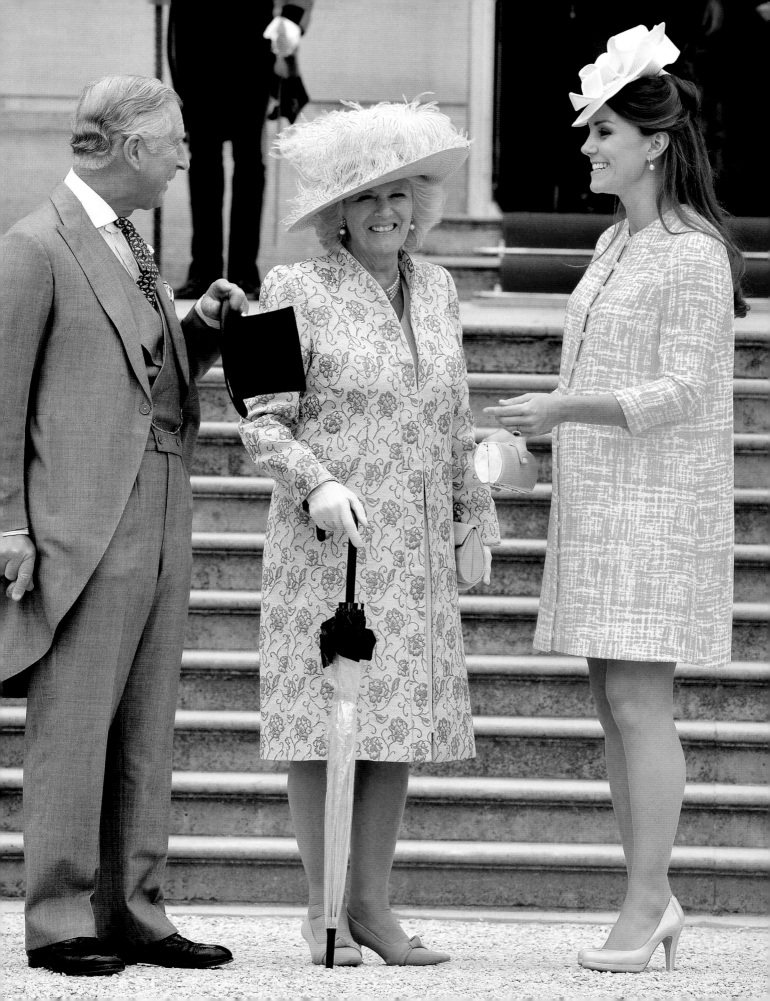

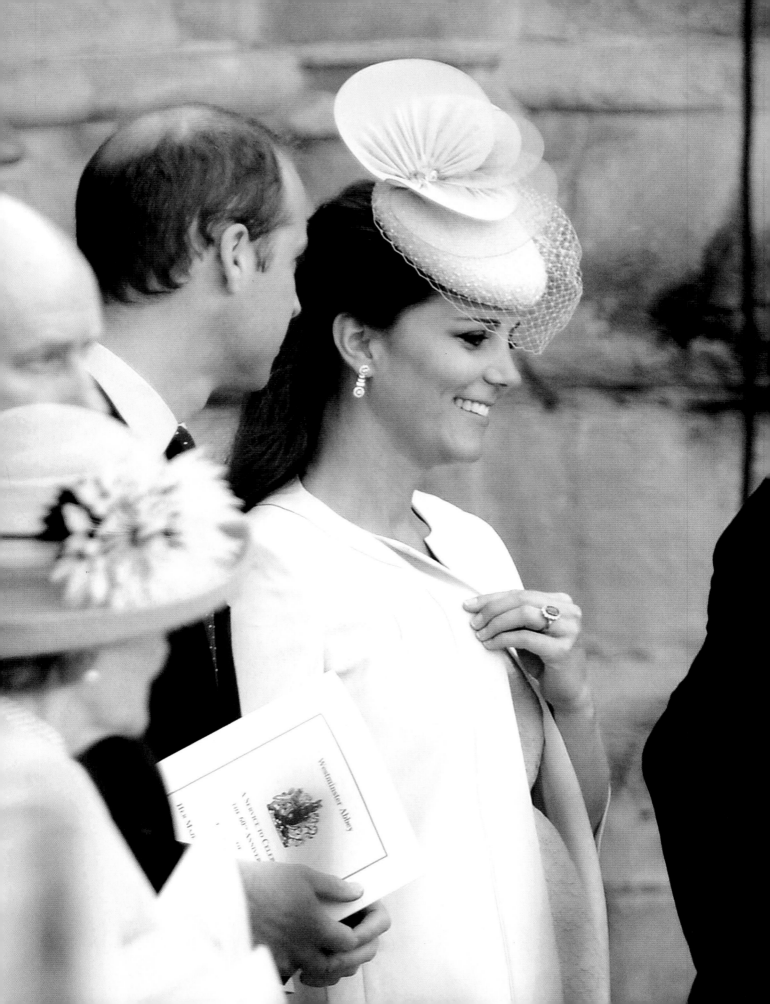

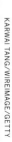

SUDDENLY IT IS JUNE, and Buckingham Palace has been so good as to divulge a due date: mid-July. This is very helpful to tabloid city desk editors and block party planners throughout the land. As the final countdown begins, there are still Windsor family events that are not to be missed. Preeminent among them is the 60th anniversary of Queen Elizabeth's coronation at Westminster Abbey. This is not a blowout on the order of 2012's Jubilee celebration, but rather as intimate a gathering as a ceremony in grandiose Westminster can be. On June 4, the Duchess of Cambridge is escorted into the cathedral, during which time she is said to "glow," by her husband (opposite). Above: She greets the celebrant, Justin Welby, Archbishop of Canterbury—her Fascinator as fascinating as his. High-ranking Anglican prelates in London have more work shortly in store: a royal christening.

The *Little* Prince!

They sure did keep us on tenterhooks.

The summer weeks wound on, Wimbledon yielded to the Open Championship, which also came and went, and still no news—no town crier, no proclamation in the forecourt of Buckingham Palace.

The duchess had disappeared, though her whereabouts were generally known. The media scrum outside the Lindo Wing of St. Mary's grew increasingly restive in the uncharacteristic London warmth, and even the queen showed some impatience. "The Great Kate Wait," it was called in a moment of whimsy. This was funny briefly, and then: *C'mon, m' dear, the world can't hold its breath forever. Let's get on with it!*

Which she did, at 4:24 p.m. on July 22, with her little prince weighing in at eight pounds, six ounces—statistics instantly known by all British subjects and royals watchers 'round the globe. Within moments, sales of the Guardsman Sleep Suit at the Royal Collection Trust Shop spiked. William spoke for himself, his wife and, frankly, for all of us when he said, "We could not be happier."

The news of the next several hours and days was all about line of succession (the fresh prince is third behind his grandfather and father) and other royal prerogatives (the young man may inherit a fortune of $1 billion one day), but that kind of thing seemed a bit unseemly. It was better to focus on the joyous event itself, and on the happy, thoroughly modern parents. William was present at the birth, as dads are allowed to be these days. Kate only spent a day in the hospital before being released, as moms can these days. William had to double back inside for the baby carrier, which was of sturdy and safe plastic—no gilt at all. Except for that crazy town crier guy from central casting, this was the very model of the modern major royal birth. Dad would drive the car home.

Kate, impossibly lovely, emerged from the hospital in a blue polka dot frock—certainly a Lady Di tribute frock. Thirty-one years earlier Diana had emerged from the Lindo Wing with baby Wills in her arms. Her dress was teal, true, but so much else was just the same. Here, now, was William grown: the proud father. What a long and truly strange trip it had been for the Windsors, from that moment to this one. What a fine point to have arrived at.

ON JULY 23, 2013, William is surehanded as he cradles his day-old son while greeting the well-wishers outside St. Mary's Hospital. He gives out bits of news— he had already changed his first diaper, for instance— but says he and Kate are "still working on a name." A day later, they've decided: George Alexander Louis.

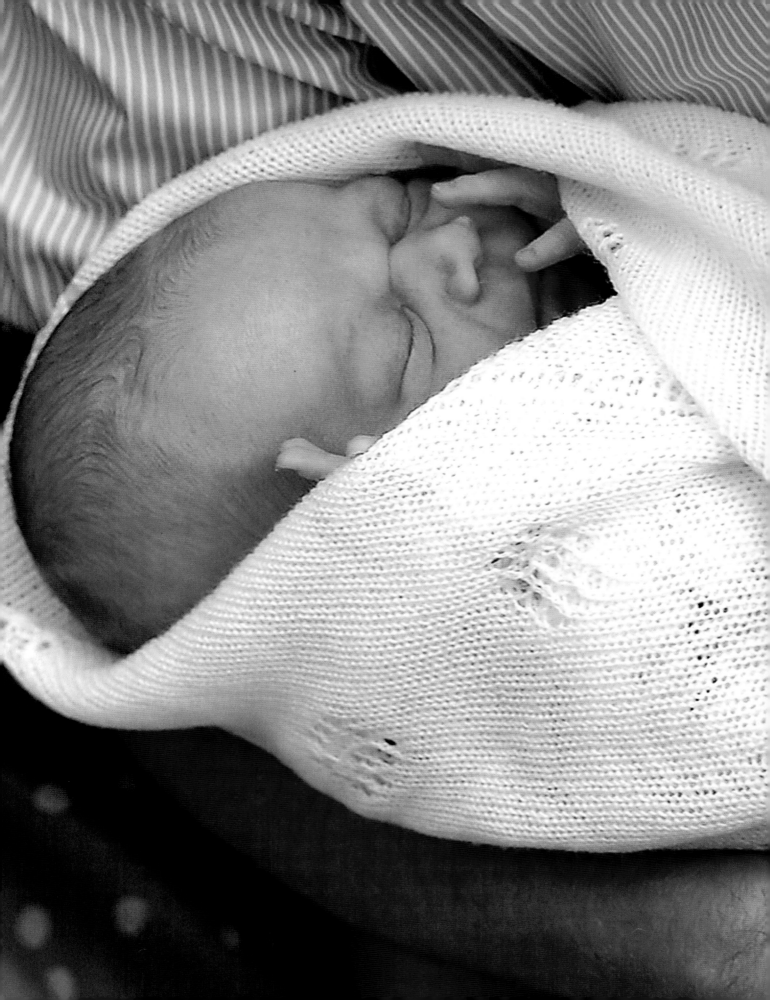

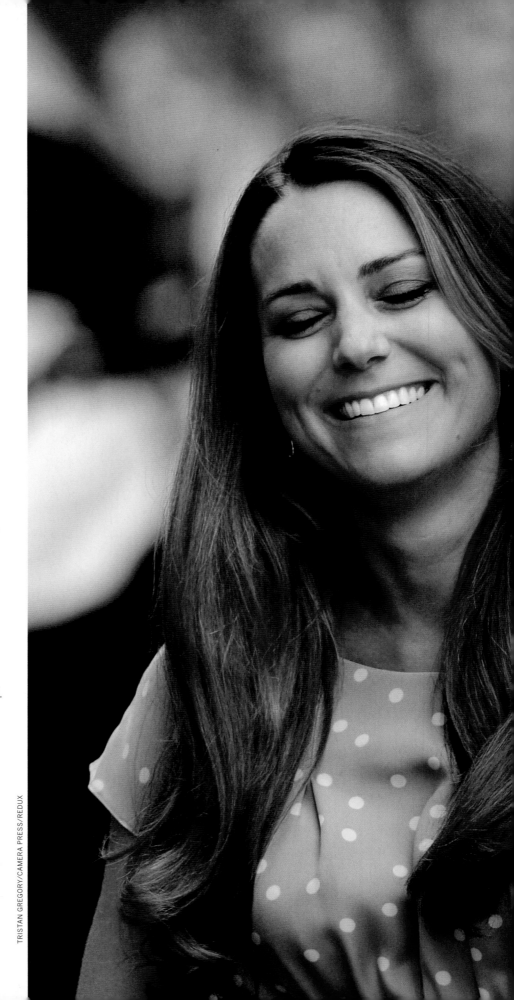

MERRIE OLDE ENGLAND
was rarely if ever merrier than it
was upon the arrival of the royal
baby. The King's Troop Royal
Horse Artillery fires off 41 shots in
Green Park, while the Honourable
Artillery Company at the Tower
of London bests them with a
62-round cannonade. The bells
of Westminster Abbey peal for
three hours, while at Buckingham
Palace the Cliff Richard song
"Congratulations" is played
during the Changing of the Guard.
All the other British babies born
on July 22 are gifted with a royal
silver penny in commemoration
of the memorable day. Because
the public is so very eager to see
the baby and his parents—or
maybe because the couple figured
they had kept everyone waiting
long enough already—William
and Kate don't dawdle, exiting
the hospital the very day after
the birth.

TRISTAN GREGORY/CAMERA PRESS/REDUX

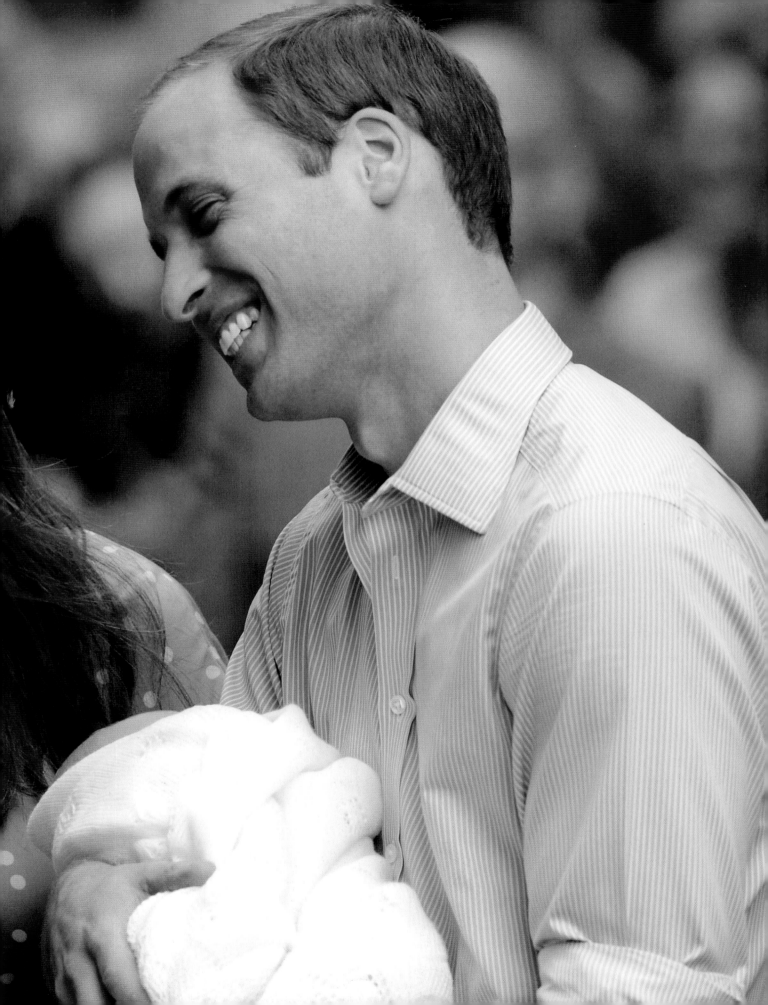

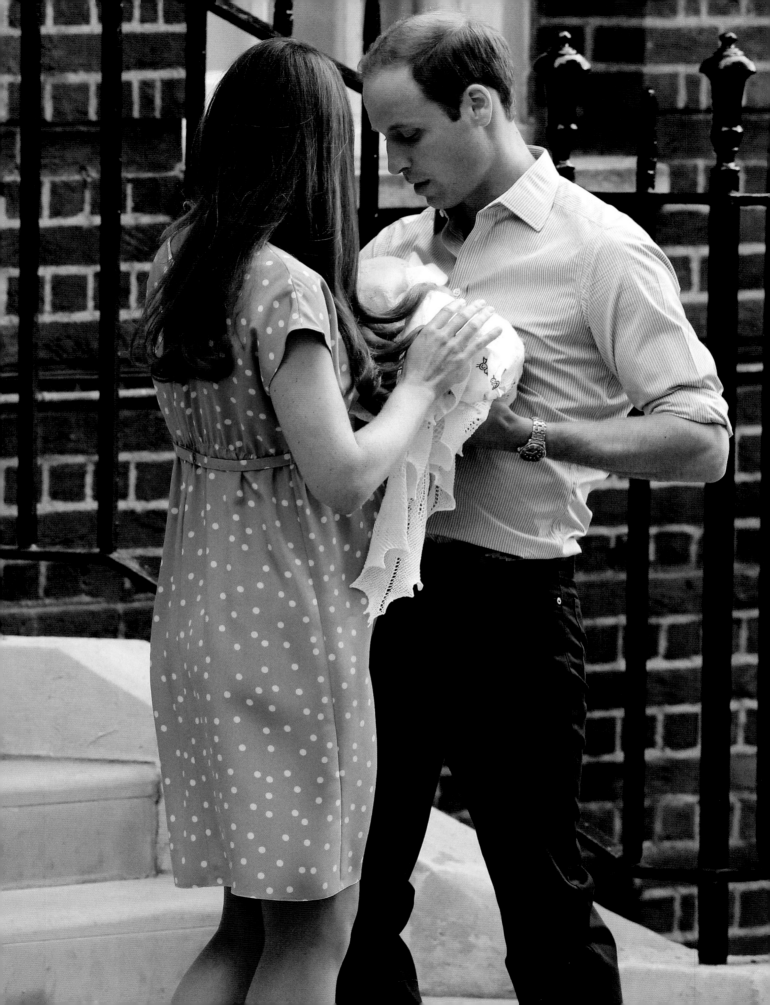

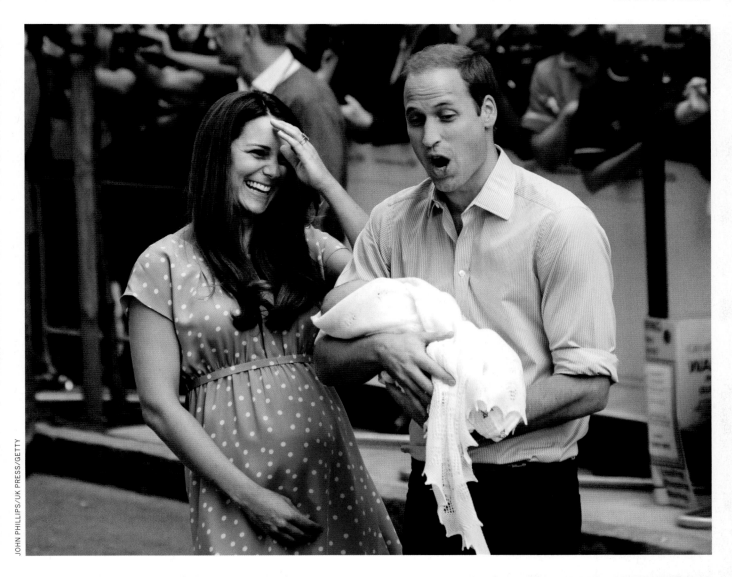

JOHN PHILLIPS/UK PRESS/GETTY

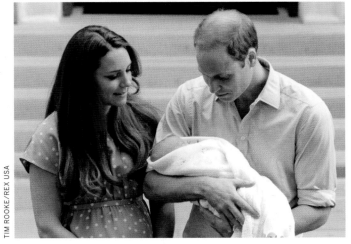

TIM ROOKE/REX USA

YIN GANG/XINHUA/LANDOV

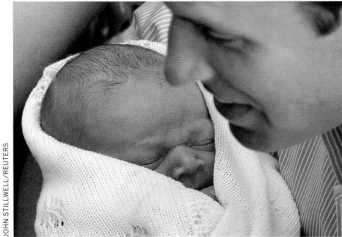

JOHN STILLWELL/REUTERS

WILLIAM AND KATE are clearly over the moon, and the prince's great good humor is on fine display at the hospital. He jokes that his son already has more hair than he does, and when the couple is asked which parent the baby more closely resembles, William responds gallantly: "He's got her looks, thankfully."

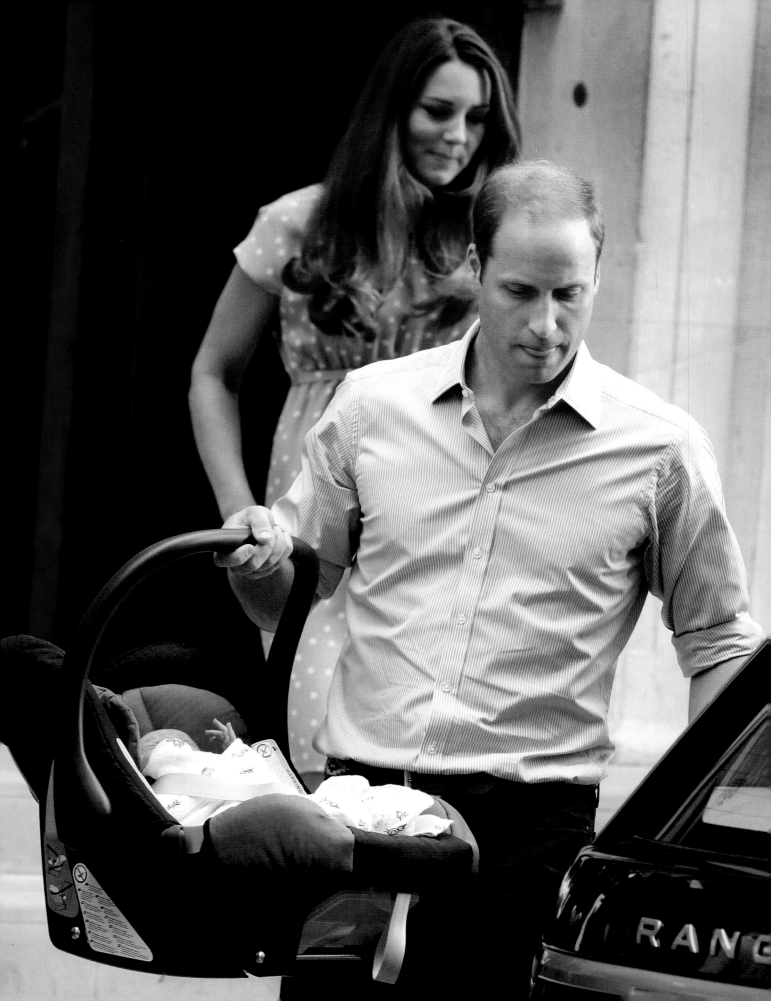

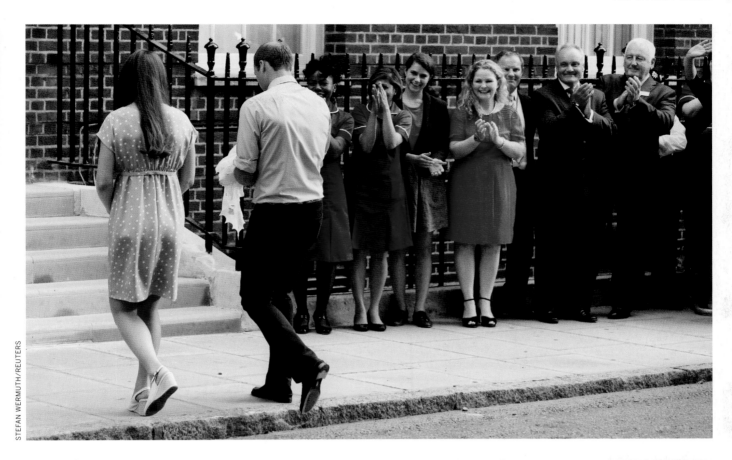

STEFAN WERMUTH/REUTERS

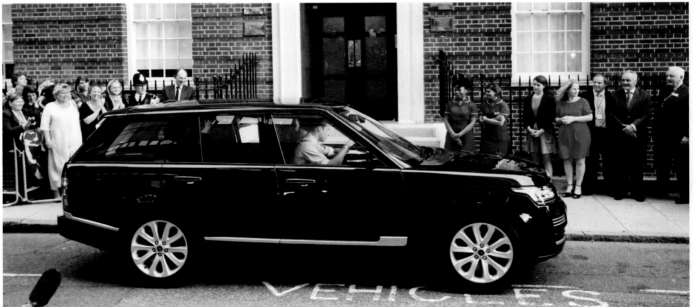

LEFTERIS PITARAKIS/AP

YUI MOK/PA/AP

WILLIAM SURELY could have arranged for a driver, but that's not his style, and when they retrieve the baby-seat from the hospital (top and opposite), he takes the wheel of the Range Rover himself and drives off to Kensington Palace with his wife and new son. Lost on no one is the thought that 31 years earlier William had made a similar trip from St. Mary's with his own mother. Pippa and Harry pay a visit at the palace and the queen, too, drops by; then, only two days after the birth, the happy family is off to Bucklebury for a stay with the Middletons.

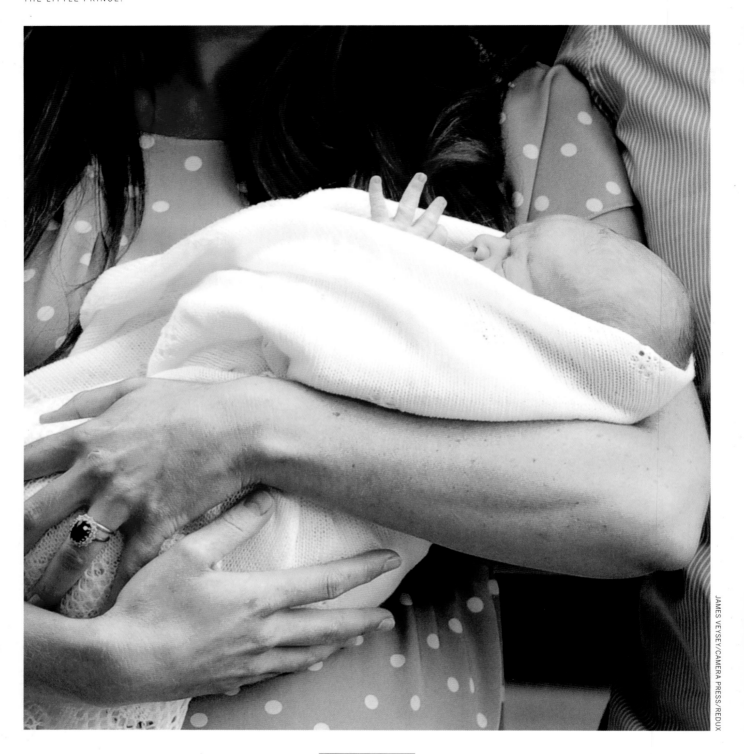

WHEN LADY DIANA SPENCER became engaged to Charles, Prince of Wales, in 1981, she chose as her engagement ring a blue sapphire set in white gold and surrounded by 14 solitaire diamonds. Upon Diana's death in the 1997 car accident, Charles allowed his sons to select certain keepsakes to remember their mother by. Prince Harry chose the ring, but later gave it to his brother so that he might honor Kate with it. And so it was that the ring, too, conjured memories as Catherine, Duchess of Cambridge, cradled her newborn son, who will be called George, on the steps of the Lindo Wing—the precise spot where Diana and Charles had shown their firstborn son, William, to the wider world.